# LEARN TO DRAW IN 5 WEEKS

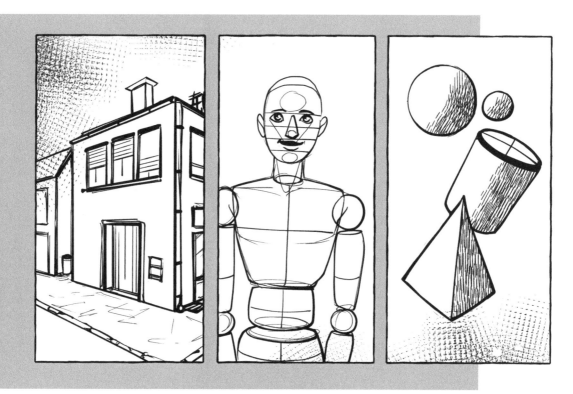

# LEARN TO DRAW IN 5 WEEKS

## A Beginner's Workbook for All Ages

**KritzelPixel**

ZEITGEIST • NEW YORK

Zeitgeist™ is a trademark of Penguin Random House LLC
ISBN: 9780593435977
Ebook ISBN: 9780593690154

Illustrations and photography © by envato elements
Interior design by Isabel B. Zimmermann
English translation by Christina Stinn

Printed in the United States of America
1st Printing

"Learn to Draw in 5 Weeks: A Beginner's Workbook for All Ages" by KritzelPixel was first published in 2020 under the title "Zeichnen lernen in 5 Wochen" by Yuna, a division of Penguin Random House Verlagsgruppe GmbH, Munich, Germany. Copyright © 2020 by Yuna, an imprint of Penguin Random House Verlagsgruppe GmbH, Munich, Germany.

First American Edition

# CONTENTS

**WEEK 1**

*Fine Motor Skills*

11

**WEEK 3**

*Shapes*

41

**WEEK 2**

*Dimension*

27

**WEEK 4**

*Shadows*

63

**WEEK 5**

*Craft*

77

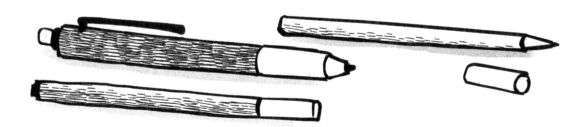

# THIS IS KRITZELPIXEL

## Isabel B. Zimmermann

Dear drawing friends,

Welcome to my workbook *Learn to Draw in 5 Weeks*. I'm Isabel. I've been drawing my whole life, though it wasn't until I was older that I finally learned how to do it properly. I used to think that if only I drew more often, I'd improve eventually. But that didn't work so well, because with slow progress I became frustrated.

I don't want you to have the same experience, which is why I've created this step-by-step guide to teach you the fundamentals of drawing. In 80 pages, I will provide you with the main skills you need to refine your drawing craft. You'll also get tips and links to access online resources if you want to learn about a particular topic in more detail. Decide for yourself how much you want to immerse yourself!

If you're curious about who I am and what I do, you can visit my YouTube channel. I started to upload drawing tutorials in 2009, when my comics readers wanted to know more about how I work. Later I founded kritzelpixel.de.

Some of you may also know me as Honeyball from my gaming videos.

I've been working as a freelance artist for more than 10 years now. I make a living from writing books, drawing comics, creating illustrations, giving talks, and streaming on Twitch, a livestreaming platform for gaming.

You can purchase my other books and comics on my website. Perhaps you'll find something you like!

And now, I wish you the best of luck.
I hope you enjoy this book!

Best wishes,

Isabel

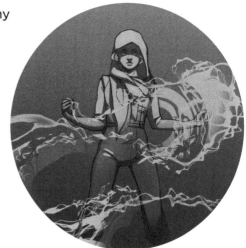

# MY PHILOSOPHY

## A Beginner's Workbook for All Ages

Drawing is supposed to be fun! You don't need to be talented; anyone can learn to draw, and we each progress at our own pace. In this book, we cast aside our desire for perfection and have no expectations. That's because even stick figures can tell an exciting story! What you need is a little courage to express yourself. The most important thing is that you enjoy creating and learning. Drawing from scratch is very difficult—we all need practice. Learning how to draw means rendering your desired image based on a few references. To do this, you need to be able to recognize shapes and bring them to life on paper. It requires fine motor skills to show three dimensions on a two-dimensional piece of paper.

Add a pinch of creativity and skillful composition, and you can make dragons come to life. I'll teach you everything you need to know in five weeks!

How to use this book: You'll find several exercises and step-by-step instructions throughout this workbook, as well as practice exercises for every day of the week at the end of each chapter. Start by reading the chapter for the entire week before you begin the exercises. From there, you can complete several exercises in one day, or you can tackle one every few days. How much you do is up to you, but you should do the exercises in chronological order.

You can always draw more if you like. If you're already more advanced, you can use week 1 as your warm-up week.

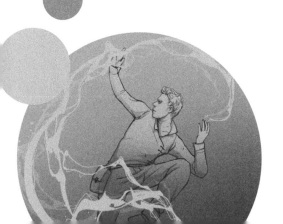

Let's start with an example right away. You can draw along—just grab any pencil or pen you have on hand.

You can find more information on the drawing materials needed for this book on page 14.

# COMPLETE THE PATTERN

Here you can see a pattern with weaving lines and empty spaces between them. Let's fill in these spaces by drawing high arcs in them.

This is tricky initially, but you'll get better over time. I discovered this pattern on Pinterest years ago, and it gave me a better understanding of lines and forms.

*The only things you need for this exercise are concentration and patience.*

**1.** The arcs I draw into the shapes have a high point. It should sit around halfway between the two weaving lines that create the curvy shape. I've shown this with a straight line in the picture on the right.

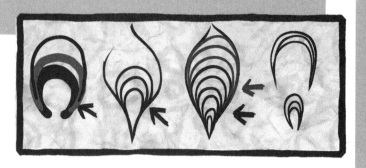

**2.** I start the next arc close to the beginning of the previous one and bring it back down on the other side. You can see that the arcs create a tight pattern.

**3.** Note how getting the curve of the arc right makes all the difference.

*You can also draw straight lines into the empty spaces if you like.*

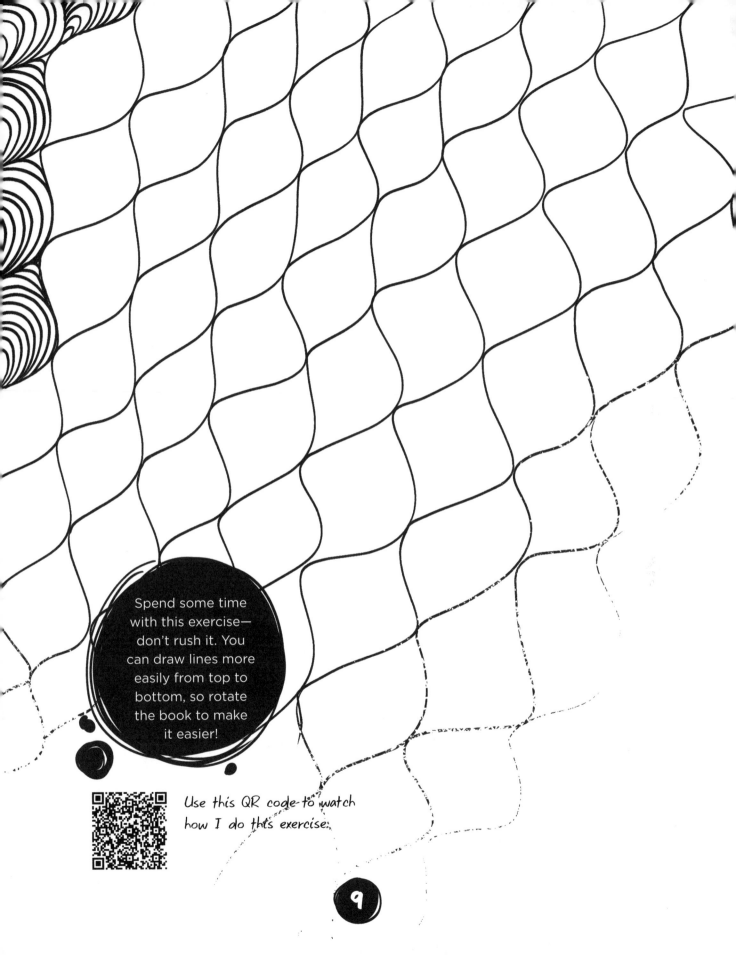

Spend some time with this exercise—don't rush it. You can draw lines more easily from top to bottom, so rotate the book to make it easier!

Use this QR code to watch how I do this exercise.

# WEEK 1

*Fine Motor Skills*

Read everything for week 1 before you start with your daily drawing exercises, which begin on page 17.

This was drawn with a ballpoint pen.

This was drawn with HB and B pencils.

This was drawn with pastels and charcoal.

Art is an expression, so there are no formulas for it. However, if you want to render a particular image—draw a portrait, for example—there are a few basic principles you can follow to transform the image you have in your mind into a realistic piece of artwork. Drawing is a skill and a craft you can hone and refine.

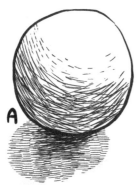

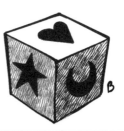

We always begin with an object we want to create. Let's call it a shape. A shape we draw consists of lines. (Figure A)

The lines of a shape can make us believe that we see a three-dimensional object. For that to work, they have to follow certain rules—especially in terms of perspective. The famous cube is a great example. (Figure B)

Like this, the shape is a square. But add just a few lines, and it becomes a cube. (*Figure C*)

If the lines don't follow certain rules, we see right away: something's not right. (*Figure D*)

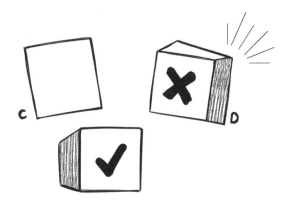

The second important key to creating realistic, three-dimensional drawings is showing light and shadow, because it's the difference between the light and dark areas that lets our brain perceive spatial depth and perspective.

Why does this cube look three-dimensional? The lightly shaded area you see is enough to suggest its dimension. It doesn't even have to be black, gray, and white, as shown here. (*Figure E*)

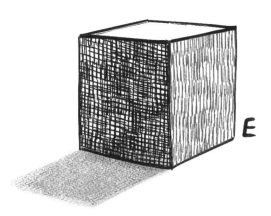

# SUMMARY

Shape + perspective + light and shadow + creativity = drawing

Generally, anyone who puts their mind to it can draw.

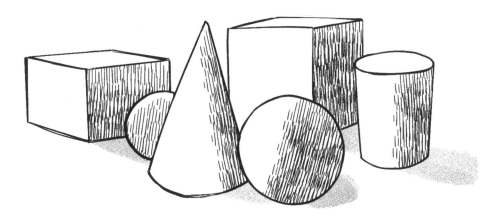

A ballpoint pen will work for most exercises in this book. Drawings mainly consist of lines, which you can easily create with a pen.

"A pen?" you might ask. "But then I won't be able to erase anything!"

The point of many of these exercises is to accept mistakes and learn to live with crooked lines. Of course, you can use a pencil, too. You just have to decide how much time you want to spend with the eraser. Some drawings are much more easily created with a pencil and a good eraser. I love using pencils with a hardness grade of H, HB, B, and B2. Grades that include the letter B are softer, while grades that include H are harder. The softer the pencil, the darker it is. Soft pencils are also great for blending—you can use a tool called a blending stump for this.

But there are more drawing tools besides pens and pencils. In the following section, I'll show you different materials at various price points. You're also welcome to complete the exercises on a tablet.

# DRAWING MATERIALS

## Blank notebook

You can use any 8.5 x 11-inch notebook to complete the exercises, as long as it's unruled!

## Pen, fineliner, gel pen

It's useful to have a black pen and a light-colored gel pen—pink, for example—that can be used for sketching before adding in black.

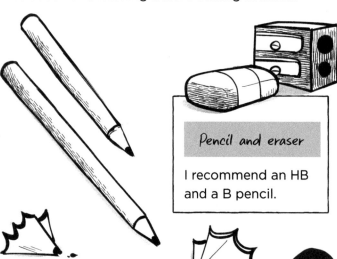

### Pencil and eraser

I recommend an HB and a B pencil.

## Inexpensive magazines with photos

In some exercises, you'll trace an image from a reference. Photo magazines, tabloids, etc. are great reference materials to practice with.

14

## Pencil sharpener or mechanical pencil

If you don't like to sharpen pencils, you can try a mechanical pencil. You can even get them in color.

**Blending stump**

Most craft stores have them. Use this tool to blend your charcoal or pencil drawings.

**Compass, ruler, and protractor triangle**

Not necessary, but they can come in very handy for a few exercises, preliminary sketches, etc.

**Drawing paper**

The brands Clairefontaine and Canson make good drawing paper. I also recommend tracing paper to place on top of a reference.

**Acrylic marker**

Use acrylic markers to sketch on magazine photos or to write on adhesive tape.

**Rubber band, adhesive tape**

In particular, thin rubber bands can be pretty helpful. You'll see later on page 44.

The week 1 exercises are great for familiarizing yourself with new drawing materials, so use them to experiment with gel pens, fineliners, etc. That way, you can see how these tools feel before you create your own drawings with them.

## Charcoal and chalk

Not necessary but very useful for some exercises. In this book, I won't go into detail on how to use charcoal and pastel pencils. Those of you who are already familiar with these tools can experiment with them, but they are not easy to work with.

15

# HOLDING A PEN

Holding a pen, drawing accurate lines, and controlling your hand while drawing circles, spirals, and straight lines are essential skills to master.

Drawing techniques are often described at the beginning of drawing books, but this approach asks a lot of a beginner because they aren't easy to master right away. Let's start small. First, we'll work on your fine motor skills. Once you're proficient with them, you'll be able to draw a line, a curve, or a circle with confidence.

### How do you draw a circle?
The trick is to let the movement come from your arm and wrist. You should draw a circle or an arc swiftly. Don't sketch! Create the shape in one smooth movement. You can always refine it and make small changes later.

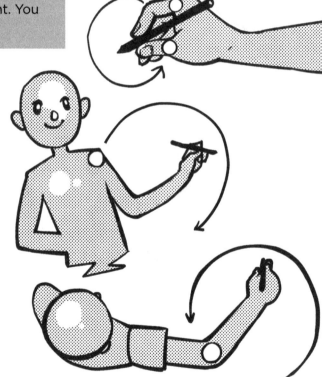

### How do you draw a line?
Swiftly and deliberately. Move your arm from your shoulder or elbow joint. It's easier to draw from top to bottom than it is from right to left.

This week we'll practice all of this. Don't be discouraged if you don't get the hang of it right away! There are people who can draw and paint even with their mouth or feet—it's all a question of practice, patience, and time. Don't let yourself feel pressured by the schedule set for weeks 1 through 5. If you need more time, that's okay.

### How do you hold a pen?
Hold the pen so you can draw a line without applying any pressure. Stay relaxed and keep your grip loose. Try to remember this as you work on the first exercises.

### Why is this so important?
You first have to know how to draw a circle before you can draw a sphere in 3D.

## Exercise: Warm-up Doodle

Before I start to draw, I always do a bit of wild doodling. This exercise warms me up and relaxes my hand muscles. The goal here isn't to be accurate; it's to have fun.

I've already started on this page—feel free to complete it. Fill every square inch of space in the rectangles with circles, lines, and spirals. Apply either a lot or a little pressure and try each pattern.

Each day, before you begin any of the exercises, fill an entire sheet of paper with circles, lines, and other doodles. Use the movement from your wrist, shoulder, and finger joints. Experiment with the amount of pressure you use. Stay loose.

**Tip:** Grab a blank piece of paper and draw random circles across the entire page. Don't stop or lift your pen off the sheet, and engage your whole body to create the round shapes.

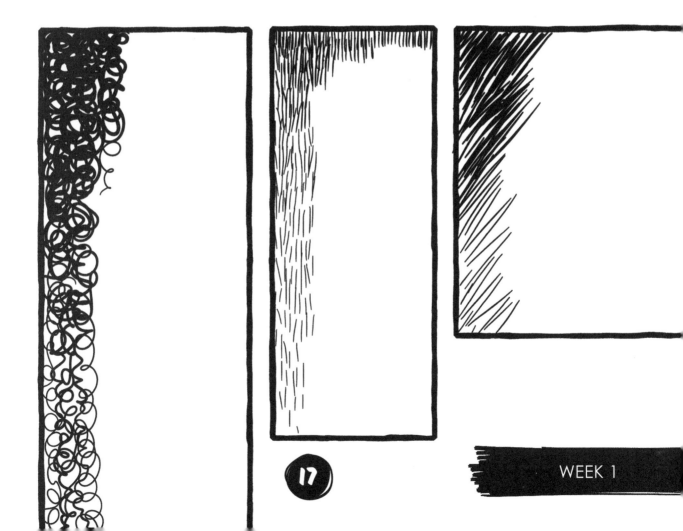

## Exercise: Warm-up Patterns

Let's continue with a few systematic exercises. You probably remember your time at elementary school and the many exercise books you had to fill with single letters before you could write without having to think about it. It's the same with drawing. You can't draw lines, circles, curves, spirals, or arcs without practicing them first. That's because you'll overthink it and start to hesitate, and then your hand will get shaky. So, let's practice!

Copy the pattern you see in the left square into the empty space next to it. Make sure that the arcs are even, the lines are parallel, and the circles are as round as possible. Vary the speed of your hand. Experience will teach you which way is best for you to create these shapes. **Important:** To practice controlled, clean lines, avoid too many short, scribbly strokes.

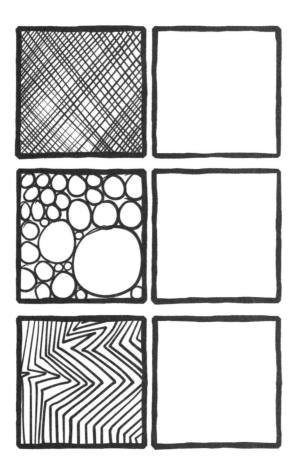

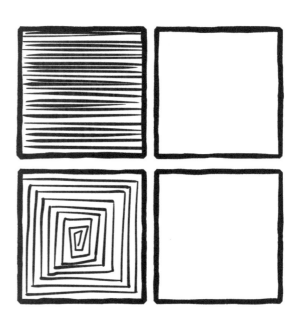

**Tip:** If you want, you can fill 10, 20, or even 30 sheets of paper just with circles and lines. The more you practice, the faster you'll get to where you want to be.

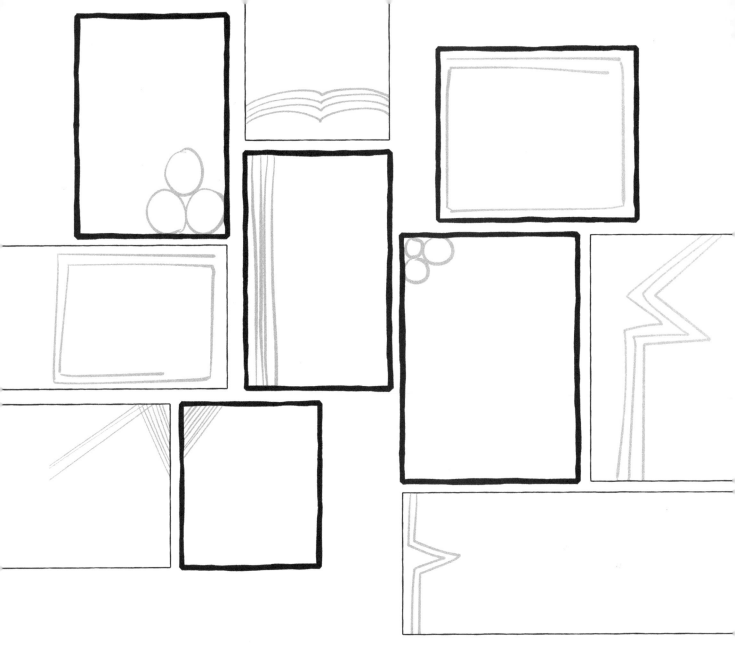

I've intentionally kept these patterns simple. Copy what I did here to fill this page. I've already created separate boxes for you. You can also come up with patterns of your own. The internet can offer great inspiration (look up "Zen doodle").

## Exercise: Dots Warm-up

Doesn't this look a lot like connect the dots? This exercise is similar. The goal is to draw a line from one dot to the next without making it look squiggly or wavy. That's quite difficult at first, which is why this exercise is so important. You can actually find this exercise in drawing books from a hundred years ago, so it's been tried and tested. You can easily create this type of exercise yourself.

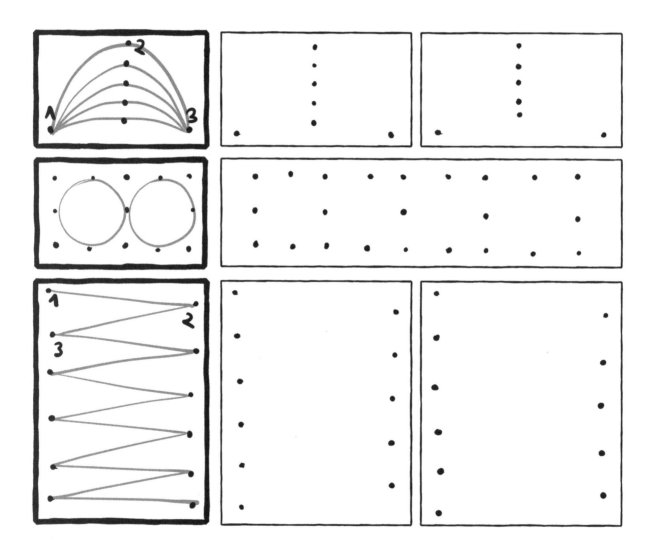

Simply copy what I did here.

# DIY PRACTICE SHEET

Start by drawing a grid without a ruler—don't worry if the lines aren't completely straight. The pressure of your pen, the movement, and the speed all affect how they turn out. Afterward, fill in the squares with the practice patterns I showed you (see page 18). Then add dots (see page 20), and use lines and arcs to connect them.

**Remember:** Don't use too many short strokes! Vary your speed between slow and fast. You'll hone your fine motor skills by repeating this exercise over and over.

As you can see, it's not about perfection. My sheet also looks a bit messy sometimes, and that's totally okay. People aren't made to draw perfectly straight lines without a ruler, so don't worry too much about it.

You can combine all the exercises if you like.

Fill a third of the page with doodles (see page 17), another third with a grid filled with different patterns (see page 18), and the remaining third with the dots warm-up exercise (see page 20).

WEEK 1

# ALL ABOUT THE CURVE

**Why so many curves?**
The answer is simple: we find round shapes in nature all the time. For example, look at how curvy a human body is and how rounded a tree appears. *(Figures A & B)*

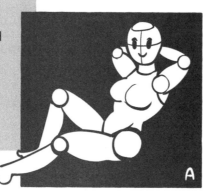

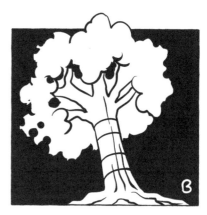

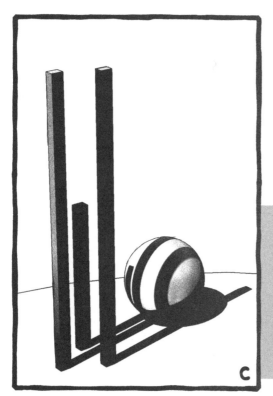

And here you can see how a straight post casts a shadow onto a round object. *(Figure C)* Fascinating, right? On a flat surface, the shadow is as straight as the post, but on a sphere it curves around the contour of the sphere. Curves are everywhere. To draw them, you need to steady your hand. And that's why you have to learn to draw curves in a deliberate and controlled fashion.

Hand-eye coordination and fine motor skills are your starting points. And here's the beauty of it: there are no mistakes when you practice.

Everything you see around you consists of curves and lines. Even children's drawings already contain elements of these simple shapes. And that's also how we'll keep our training: simple.

# Exercise: Beach Ball

You've probably seen beach balls and their simple print pattern. This exercise is similar. It introduces you to the concept of perspective (which you'll study in week 2) by having you draw a line around or along a shape. I'll go into more detail later—for now, just copy the images you see below into the empty shapes next to them. Again, repetition is key here.

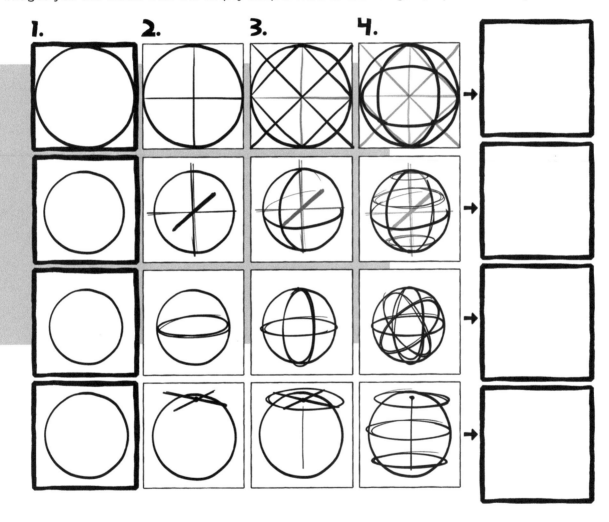

*This video has more background information on this exercise. It includes elements from week 2, when I'll teach you about drawing with perspective.*

## Exercise: Complex Doodles

Let's take a stab at more complex patterns.

If you search for the term "Zen doodle" online, you'll find many fascinating patterns with which to fill these shapes—or use my templates. In this exercise, there's once again only one goal: learning to draw accurate lines! Of course, you can also create your own patterns. The ones presented here combine what you've learned from the previous exercises in week 1, but you can easily modify them.

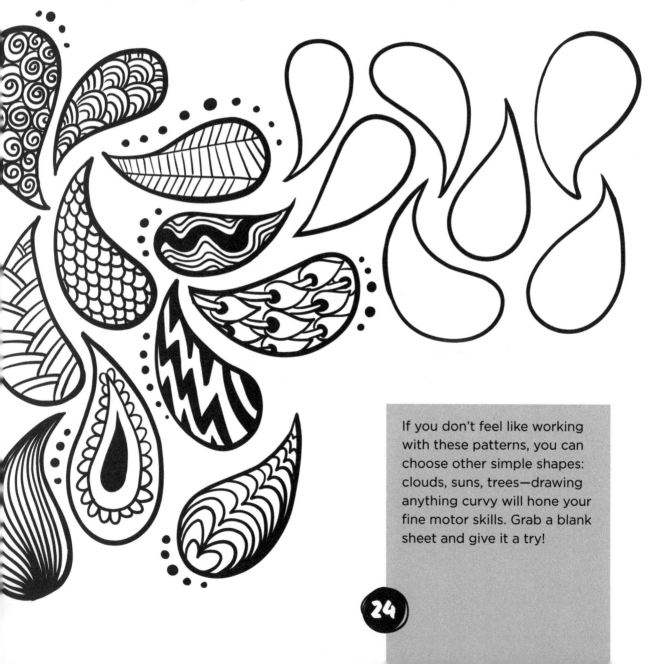

If you don't feel like working with these patterns, you can choose other simple shapes: clouds, suns, trees—drawing anything curvy will hone your fine motor skills. Grab a blank sheet and give it a try!

# PRACTICE SCHEDULE
# WEEK 1

**Day 1:** Complete the exercise on page 17. Dedicate this day to simple doodling. Practice your fine motor skills, draw fluidly, and use the joints in your arm.

**Day 2:** Start with basic doodles (see page 17), then create the simple patterns on page 18.

**Day 3:** Today we're doodling, creating patterns (see page 18), and connecting dots (see page 20). Fill a small blank sheet of paper with these three exercises—for the next five weeks and beyond. This can be a portion of your notebook paper, for example, a half or quarter of that (or any blank) page.

**Day 4:** Start with a warm-up, then complete the "Beach Ball" exercise from page 23. Repeat it as often as you like.

**Day 5:** Warm up, then fill an 8.5 x 11-inch sheet with complex doodles (see page 24).

**Day 6:** Do an extreme version of the warm-up by filling an 8.5 x 11-inch sheet with doodles, followed by a sheet with simple patterns. Then fill a blank sheet with either connected dots or filled circles. When you're done, sit back and relax for the rest of the day!

**Day 7:** Warm up, then create a large random pattern. Combine all lines, spirals, and circles from week 1 any way you like to fill your sheet. Leave as little white space as possible and concentrate on what you're doing. Don't sketch! Deliberately create your lines.

Things will get more complex in week 2.

Are you ready to create exciting illusions using just lines and arcs?

WEEK 1

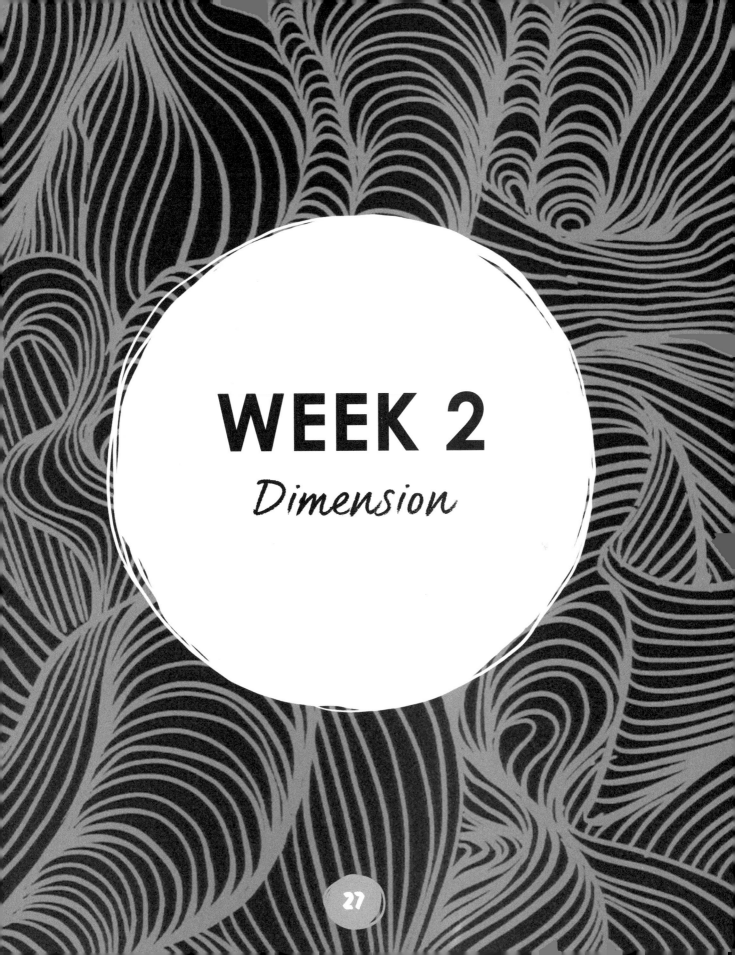

# WEEK 2

*Dimension*

Perhaps you've already worked with vanishing points in an art class in school. This popular exercise helps us to draw an object with perspective. Perspective shows us dimension and gives us the impression of spatial depth. This is why it is often taught at the beginning of a drawing class. Creating realistic drawings requires knowing how to draw using perspective. I'm not talking about photorealism here; however, the image you produce still needs to feel accurate. It doesn't have to be real—it just has to look realistic.

Drawings and paintings are illusions; we can think of artists as the magicians who create them. Their work is a deception that, in reality, only consists of pigments. Now I'll show you how you can apply some magic to your own work!

Just for fun and to give it a try, we'll start with a few exercises.

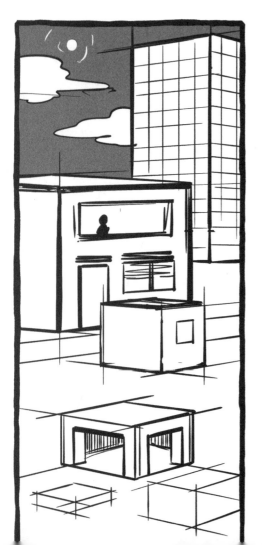

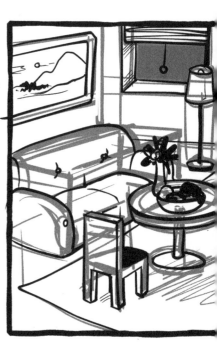

Perspective is created by drawing the height, width, and depth of an object: the three dimensions.

This image shows a street and a row of lopsided and crooked houses. It is a nice picture, but as you can see, no line is straight, correct, or realistic. The sketch very roughly follows the image at the bottom of the page, which you can use as a reference to complete the drawing. Think about which lines belong to which side. Can you guess why only lines are necessary to suggest the spatial depth of the houses? You'll learn more about this topic on the next page.

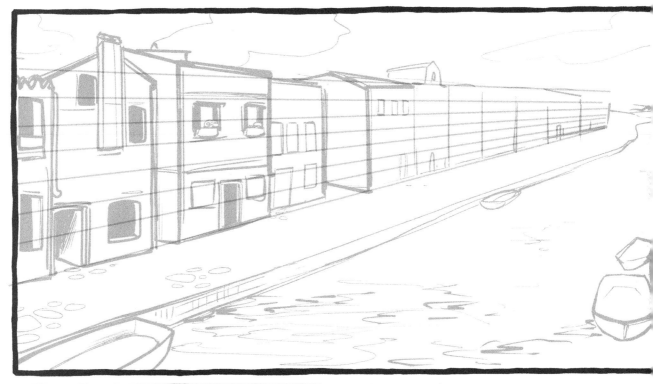

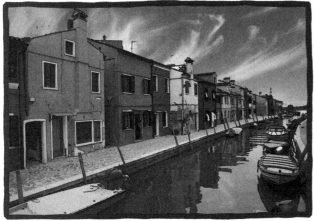

Your houses might be lopsided and crooked. That's totally okay. The point here isn't to render a great-looking drawing. I just want to demonstrate why you need to understand perspective and spatial depth.

# ILLUSIONS

You can see here that very simple lines can make a shape appear three-dimensional, even though it's just an illusion. This drawing resembles the folds of a piece of fabric, although in reality the image only consists of lines.

You can use the circles, rectangles, and lines you've practiced drawing to create the third dimension. Why do lines appear three-dimensional like that? Think back to page 22, where the shadow of a straight object fell onto a round shape, and the shadow curved itself around the shape.

Your brain is trained to identify and analyze the contrast in an image to determine what object it shows. It is essential for your survival that you distinguish light and shadow. Your brain processes lines as light and shadow, which you interpret as a three-dimensional image. This is the illusion you create with your drawings. You're tricking your brain into thinking you're looking at a three-dimensional object.

Shadows fall according to mathematical formulas, so it is possible to calculate their exact position with a ruler, protractor triangle, and compass—but that exceeds the scope of our lessons. Instead, you'll study references and copy what other artists have done to get that gut feeling for where the shadows should be. You'll learn more on this topic in week 4. **Remember:** it only has to look real, not be real.

## Exercise: Illusions

Every object consists of circles, curves, and lines. Lines either move away from one another or meet somewhere. What's important is the distances between them. Follow the lines on this page. After a few tries, you should be able to draw an illusion like this on an empty sheet of paper yourself. The trick here is to get the curve right. Set the pen down at different points and draw an arc. Play with different distances. You can create a nice effect when you have the ends of the arcs meet again, which produces these leaf shapes.

Open your mind to the world of curves and illusions.
Make sure that the transition from one line to the next is smooth.

In this exercise, you'll draw arcs between the lines, as shown in the exercise on page 8, except this time you don't have to follow the center line. And there you go: you've created the illusion of dimension! You can find more information in the video.

31

# VANISHING POINTS

Perspective and vanishing points are a complex topic that are difficult to explain on a single page. In simplified terms, a vanishing point is where receding parallel lines intersect on a page. Where they intersect, depends on the perspective you wish you achieve as an artist. The following pictures will help introduce these essential parts of drawing.

A basic principle: everything that is farther away seems smaller. That's because your eye is a lens, and you have two of them. Your two lenses look at an object from slightly different positions.

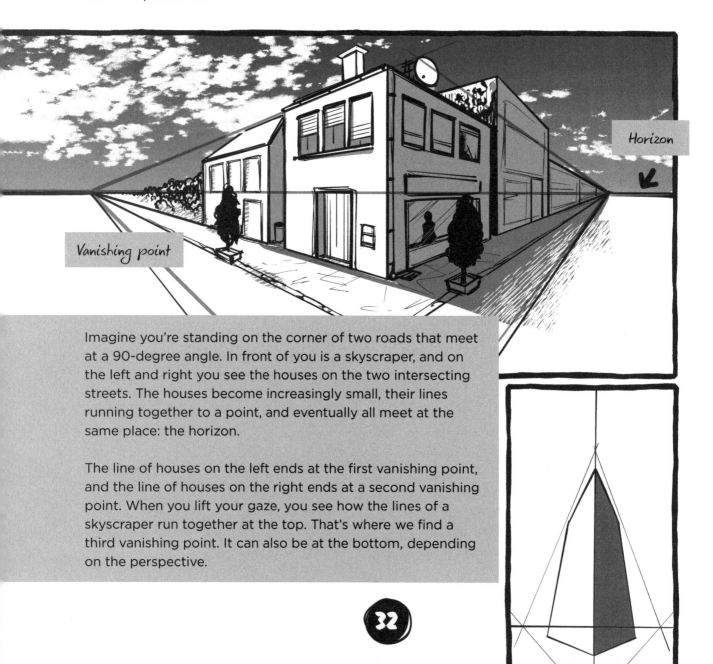

Horizon

Vanishing point

Imagine you're standing on the corner of two roads that meet at a 90-degree angle. In front of you is a skyscraper, and on the left and right you see the houses on the two intersecting streets. The houses become increasingly small, their lines running together to a point, and eventually all meet at the same place: the horizon.

The line of houses on the left ends at the first vanishing point, and the line of houses on the right ends at a second vanishing point. When you lift your gaze, you see how the lines of a skyscraper run together at the top. That's where we find a third vanishing point. It can also be at the bottom, depending on the perspective.

# PERSPECTIVE

Let's draw a cube now, one step at a time. In each step, I'll explain which lines are important. If, at a later point, you don't remember how to draw a cube, you can simply return to this page to refresh your memory.

**1.** Begin by drawing a crooked rectangle. Since you're not looking straight at the cube, you need to remember what you learned about perspective on page 32. The horizontal lines run toward a vanishing point on the horizon line—in this case to the left. Imagine they meet somewhere in the distance. The vertical lines run down the page toward another vanishing point, since you're making it appear as if you're looking at the cube from above. That's why the line at the bottom of the cube is also a little shorter.

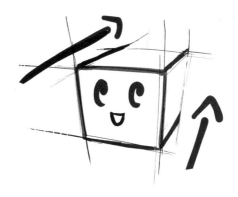

**2.** There's another vanishing point in this drawing, which is on the right. Three lines run toward it, starting at the two upper corners and the corner on the lower right.

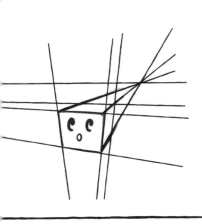

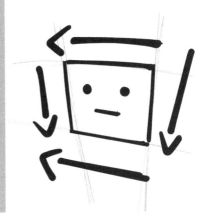

**3.** The horizontal line in the back leads to the vanishing point on the left. The vertical line in the back leads to the vanishing point below. To finish the cube, you just have to connect the remaining corners. A cube like this seems much more precise than the one on the left, doesn't it? Perspective is the key.

# MORE EXAMPLES

A three-dimensional image shows height, width, and depth.
Anything parallel to the ground follows the horizon line.

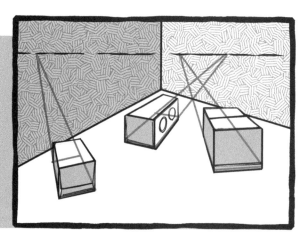

When boxes are strewn about in a room and aren't parallel to each other, they all have different vanishing points that meet on the same horizon line. The angle of the box determines the location of its respective vanishing point. The boxes are facing either to the left or to the right, so each one's associated vanishing point moves to the left or right accordingly.

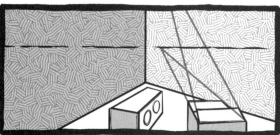

When something angles up or down (such as a lid), the vanishing point changes and moves too, in this case up or down.

Lines below your vantage point run at an upward angle, toward the horizon. Lines at eye level are level, like the horizon. Lines above your vantage point run downward, toward the vanishing point on the horizon.

Lines on round objects curve upward when they are below eye level, are level when they're level with your eyes, and curve downward when they are above eye level.

34

## Exercise: Observe

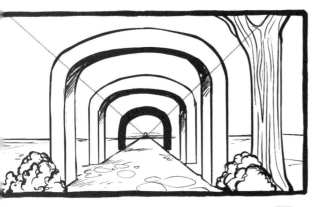

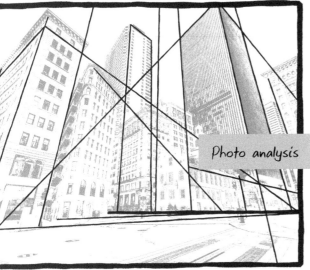

Photo analysis

Vanishing points help you to draw the height, width, and depth of an object accurately based on your chosen vantage point.

If you're working with only one vanishing point, lines that represent depth all run toward this vanishing point. This is the case when you're looking through the entrance of an archway, for example. You only need a single vanishing point because the lines are all parallel to the ground.

If you're working with two vanishing points, the lines for width and depth run toward the two points. You often see this at the corner of a house. In this example, we have many large objects (the skyscrapers), whose width and depth both run parallel to their vanishing points.

Lines that represent height run toward a vanishing point at the top or bottom. This is the case, when you're standing in front of a skyscraper on a street corner and look up.

Use real-life scenarios to study perspective. Find the horizon and move your vantage point. Photos are a good way to play with vanishing points. Simply identify the horizon and then draw the vanishing points onto them. Here, magazines are useful references.

Just take a ruler or a piece of cardboard and use an acrylic marker or another pen that will be visible against the image to draw the lines right onto the page.

## Exercise: Tubes

There is a good reason entire books have been written that exclusively cover perspective. I encourage you to look at more literature to better understand this topic. You'll find resources at the end of this book.

It takes a lot of practice to deeply understand vanishing points—even my brain works itself into knots sometimes. To warm up, let's start with a simple exercise to practice drawing perspective.

When you draw circles onto cubes, you can see how much the point of view can distort the way an object looks. And it's not very easy to draw these circles. You'll tend to produce a wobbly circle rather than one that is distorted due to your perspective.

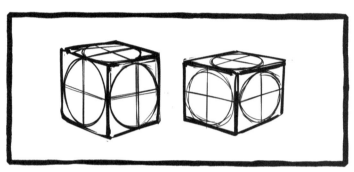

For practice, I like to recommend that you draw lots of spirals and circles. Something like what you see below, which you can draw quickly. And then simply connect it all . . .

Ta-da! You've got yourself a tube. Repeat this exercise as often as possible to train yourself to create circles viewed from an angle.

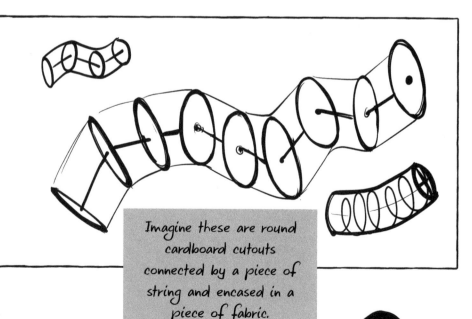

Imagine these are round cardboard cutouts connected by a piece of string and encased in a piece of fabric.

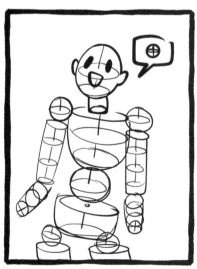

## Exercise: Box

Let's now look at a visual summary of vanishing points in perspective. Below you can see numbers that tell you the order in which I drew the lines. Simply take a blank sheet of paper and re-create the lines in the numbered order. If you're looking for a challenge, you can change the vanishing points, which will give you a different perspective. Once you know what the different lines are called, you can also follow instructions from other tutorials and books.

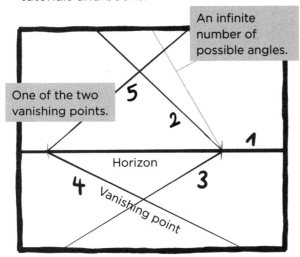

An infinite number of possible angles.

One of the two vanishing points.

Horizon

Vanishing point

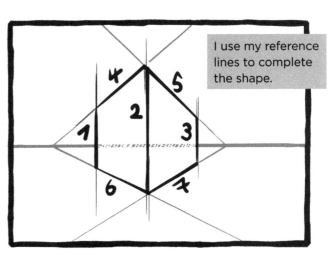

I use my reference lines to complete the shape.

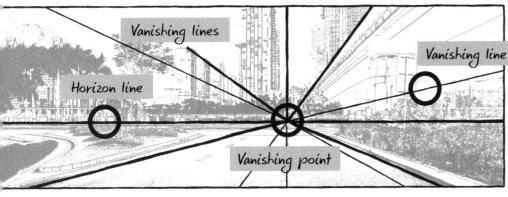

Vanishing lines

Horizon line

Vanishing point

Vanishing line

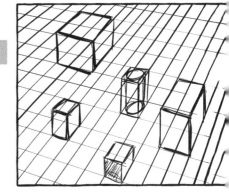

What's known as a vanishing point perspective grid can be very helpful when you first practice drawing using perspective. It's a lot of information all at once, so go slowly, read through it several times, and watch the video.

37

# ROBOT PEOPLE

Oh, will you look at that—that looks almost like a person, doesn't it? When you draw the human body, you follow the same visual principles. Perspective is important here, too.

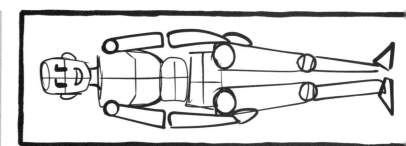

When you draw people, you need vanishing points less often. That's because if the vanishing point is far away on the horizon, well beyond the extent of the sheet where you're drawing, then the lines all look almost parallel. So you can actually just treat them as if they were!

Vanishing points are usually only important when you want to draw someone from a frog's-eye or bird's-eye point of view, meaning it appears as if you're looking up at them from below (frog's-eye) or looking down at them from above (bird's-eye).

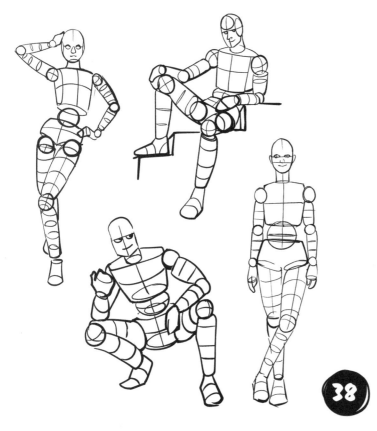

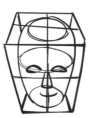

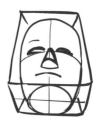

Be so kind as to draw some clothes onto these robot people—they look so eerie without them. Pay attention to the lines along the arms and legs and how they curve up or down. In this example, I applied the principle of perspective you've been learning about.

38

# PRACTICE SCHEDULE WEEK 2

**Day 1:** Warm up (see week 1), then draw six cubes (if you have a box at home, try it with a real-life prop). Finally, do the "Illusions" exercise from page 31 on a sheet about half the size of an 8.5 x 11-inch sheet of paper.

**Day 2:** Warm up, then fill two 8.5 x 11-inch sheets with tubes made up of circles, lines, and spirals (see page 36 for more details).

**Day 3:** Warm up, then fill two 8.5 x 11-inch sheets with tubes. Afterward, draw a cube, followed by a box drawn with perspective, using vanishing points and reference lines (see page 37 for more details).

**Days 4 through 7:** Warm up, then fill a sheet with tubes, draw a cube, and fill another 8.5 x 11-inch sheet with lots of boxes with perspective—remember to use vanishing points. You'll almost create a small city!

If you want, you can mix up your daily exercises, or you can draw something else. Week 2 is more monotonous because you need to get a feel for drawing accurately with perspective. If you need longer to fully grasp it, that's okay; take your time. Also watch my videos using the QR codes I've left for you throughout this book.

**Conclusion:** You can create a third dimension on a two-dimensional sheet using only circles and lines. The shapes you've seen so far have been very simple. But aren't realistic drawings really complicated? So now what? Don't worry: you can break down any complex object, including a person, into simple shapes. That's what you'll practice next week.

Finally, I want to encourage you to draw using perspective a lot. Grab magazines, draw from references, and use reference lines. Observe what's around you and categorize everything as boxes of various shapes and sizes. Your entire world will become an enormous Tetris game!

# WEEK 3

*Shapes*

Now you know how to combine lines and curves and draw them with perspective. You can also create a shape with dimension and depth. This is an important step! It will take time before you're really good at it, but you'll get there with practice.

You already know the basics, which are all you need for the next exercise.

This week, we want to understand how we can break down complex shapes into simpler ones. After all, we've only practiced with simple geometric objects so far. A person, however, is much more complicated than that. To draw complex shapes, you have to identify their different components, and you'll learn how to do that in this chapter.

On this page, we have a portrait shot.

You can break down a person's head into different geometric shapes. Just look up "planes of the head" and "Reilly Method" to learn more.

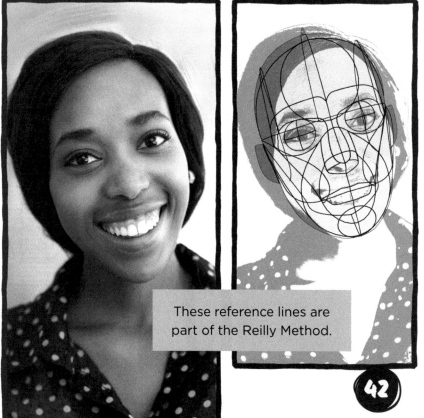

These reference lines are part of the Reilly Method.

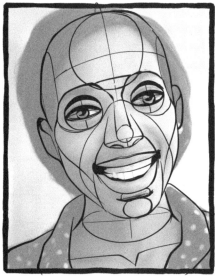

You don't have to be able to do this yet—I just want to show you where we're going with this chapter.

Identifying the planes and physical forms of an organic object with perspective is also called capturing its form. We call this the "form study process."

All artists study form, and they never stop. So don't be discouraged if your drawings don't always look great. It's a totally normal part of the process. Remember the famous saying: practice makes perfect. You will improve, little by little, and we all go at our own pace. Whether you're fast or slow, it's not a competition. This is just about you and what you can do.

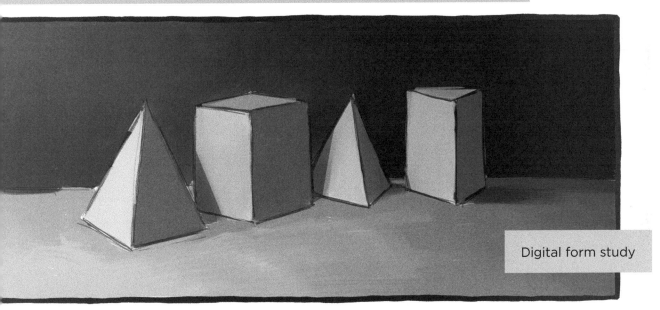

Digital form study

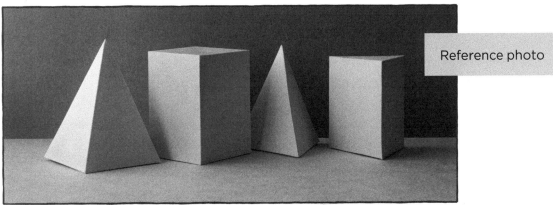

Reference photo

WEEK 3

# BASIC GEOMETRIC SHAPES

Before you start to draw people, let's first practice with simpler shapes, such as these geometric forms. You'll find similar objects in your home. Using tangible objects to study form is extremely helpful. Marbles, toy blocks, apples, pears, cups, rocks from the yard—it doesn't really matter, as long as the shapes are simple.

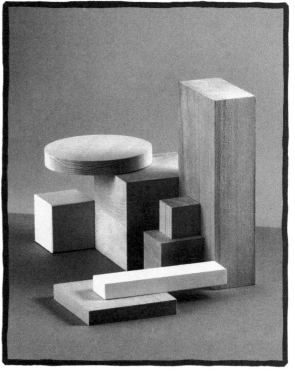

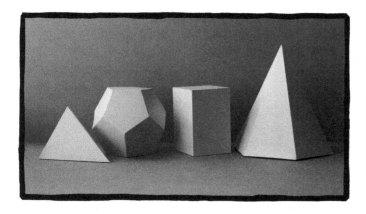

You normally need light and shadow to achieve a realistic 3D effect; otherwise everything looks flat. But what do you do when you don't know how to add them to your drawings? You can simulate the effect by drawing a grid over the object. You might have already seen this done in making-of videos from CGI films. If you apply your craft skills a bit, you can create pretty nice 3D models.

Wrap rubber bands, masking tape, string, adhesive tape, or cord around objects to create the grid. Masking tape works really well for objects with bumpy surfaces. But be careful not to damage your home furnishings.

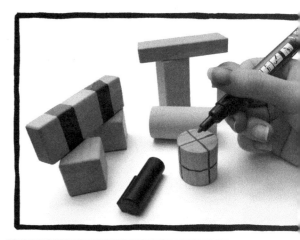

**44**

Grab a piece of paper and copy the shapes of the objects on this page. Don't overthink it—just start. You'll find a proper exercise on the next page.

# Exercise: Geometric Shapes

Here you can see simple objects of various shapes sitting on top of a reference grid to emphasize the 3D effect. These geometric forms were created with 3D software. Try to copy each of them at least four times. You'll see that it becomes easier over time. Use your thumb to measure the distance of each line.

**Remember:** pay attention to the angles; they tell you which direction a line is headed in.

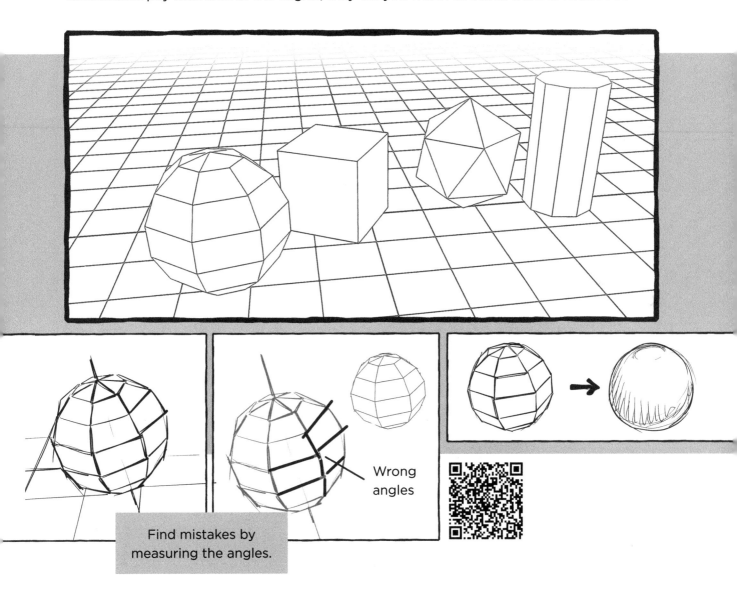

Wrong angles

Find mistakes by measuring the angles.

# STUDY SUCCESSES

Grids help you understand the various shapes you can find in the physical world. They will also come in handy later on when you learn how to shade. **Remember:** the lines mark the boundaries between the shapes and allow us to identify the forms.

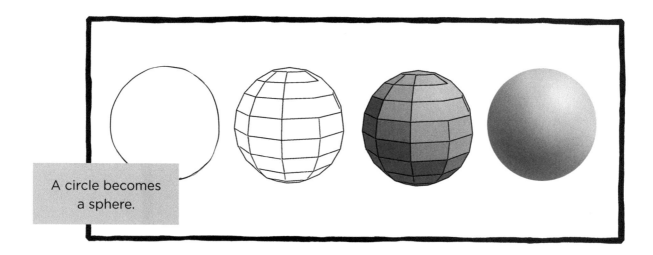

A circle becomes
a sphere.

Grids and individual shapes are the keys to understanding and drawing the structure of an object. Every line has its own angle, which you can eyeball or measure with a finger. You can also use a protractor triangle. Personally, I just eyeball it. I practice this regularly, as you will do now. In the next exercises, you will not only learn how to quickly identify shapes, but you will also get to know various forms and objects better.

This leads me to another important point: you can only draw what you already know. By studying what you want to draw, you're creating a sort of internal reference system with information on your study objects. This turns you into a better artist.

Everything in the physical world follows rules, and human bodies are usually made up of the same parts. You can use this knowledge when you draw by breaking down faces and bodies into simpler shapes and by remembering a few basic rules.

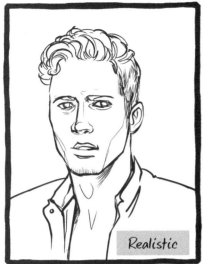
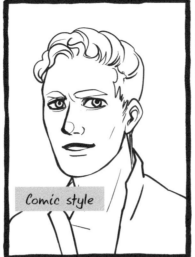

Realistic

Comic style

Scribbled figure

Let's now try to draw a human face. As different as these drawings all are, you can still see that each is a face.

Once you understand the rough basic concept of a human face, you'll find it easier to represent it with just a few lines. Each face is unique, which is why I suggest working with reference images when learning to draw—images that show you what something actually looks like. In other words: photos. You can use them to copy and understand the basic rules of more complex shapes. The internet, newspapers, plain observing, and mirrors all offer you plenty of examples to practice with.

This young woman, for example, consists of individual lines that follow the planes of her face.

It helps to draw the planes of a face onto a photo (for example, from a magazine). Then place a thin, semi-transparent piece of paper on top and simply trace the planes. This is the first step to help you better understand the angles and distances of the parts of a face.

47

## Exercise: Simplify

In this exercise, you'll break down an image into its various individual planes. Here's what you can do:

Find a photo of a face (for example, from a magazine), then grab a pen and draw the most obvious planes directly onto the image.

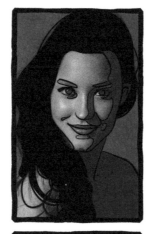

Copy these lines onto a sheet of paper. Begin with a rough outline. For example, you can draw a faint circle, as heads are typically quite round.

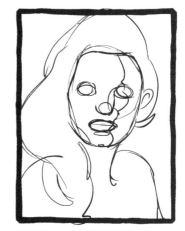

Measure where the eyes are and place reference points at the top, on the bottom, and on the sides to mark their location.

Then estimate, or use a ruler or your finger to measure, where the other lines of the face are.

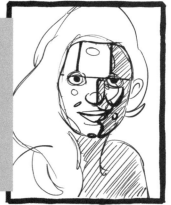

Your drawing may not be quite proportional or may look a bit flat at first, and you may not be happy with it. However, this exercise is not about aesthetics but about getting a feel for drawing a human head.

You can use the same technique to study images of cats, trees, rocks, flowers, or other objects to explore their shapes.

If you're using a ballpoint pen, you might have to start over a few times. You can use several sheets of paper for each attempt and trace as much as you want.

48

# Theory: The Nose

You'll examine the shapes of some eyes, noses, and mouths on the next few pages. This will just be the theoretical background—afterward, you'll do some exercises with reference lines to apply what you've learned. The following pages will simply give you an introduction to the topic.

A person's nose is generally an elongated triangle. If you cut off the tip and let the top of the triangle merge with the bulge of the forehead, it already looks a lot like a nose.

This simple shape is easy to understand. Next, we'll look at the more complex planes of this part of the face.

The bridge of the nose is somewhere between straight and crooked, depending on the person. The tip of the nose consists of cartilage and can be round or turned upward—in some people, it can even have a small depression. Because the tip of the nose is round, it creates many planes.

The nasal septum sits between the nostrils and is covered by skin. The nostrils form small bulges. You can draw a faint line to get a smooth transition from the nostrils to the nasal bridge and the cheeks.

You can learn to sketch various types of noses by studying the planes of a nose and by copying or tracing references. Find images of noses and practice drawing them using the method in the "Simplify" exercise (see page 48).

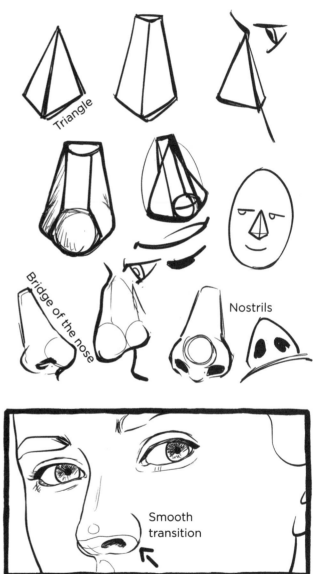

Triangle

Bridge of the nose

Nostrils

Smooth transition

## Theory: The Eye

The nose sits between the eyes, and above the eyes we have the slightly protruding forehead. The eyeballs jut out from the eye sockets inside the skull, like two tennis balls pushing out from beneath a thick blanket. The eyelids are flaps of skin that sit on top of the eyeballs. The eyeballs are perfectly round. The iris protrudes slightly, and the pupil is a hole—both are perfect circles. Depending on how much light there is, the pupil is either wide or more contracted.

The eyeballs sit within the skull and protrude slightly. The eye sockets are quite deep, which you need to bear in mind when you draw them: instead of depicting circles on top of the surface of a balloon, draw spheres sitting inside a cavity. The depth of the eyes is very important.

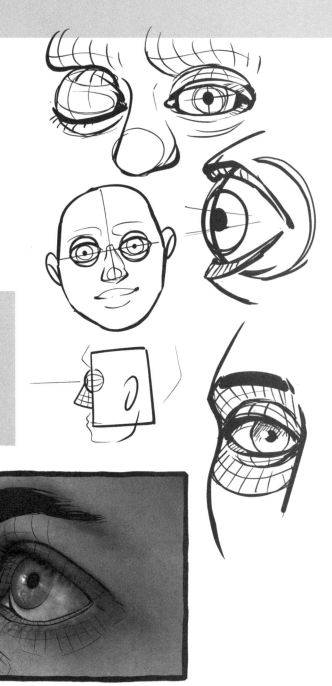

The angles, dimensions, and form of the eyes all differ between humans. Use photos to examine as many different eyes as possible and study their forms using the method in the "Simplify" exercise (see page 48).

# Theory: The Mouth

Human lips vary a lot, too: They can be soft and round, or they can be flat and simple. They can be curved or look like a bow, and they can protrude or be pulled back. The area below the bottom lip is particularly interesting but is often neglected, especially in the shading process. To keep it simple, we'll start by outlining the rough planes of the lips. In general, the upper lip protrudes strongly, and the part above the upper lip is also curved upward a little. It is illuminated when daylight falls on it from above.

When the mouth moves, it particularly affects the jaw, which determines the direction in which the lips move. We have a lot of muscles around our mouth so we can purse, pucker, and otherwise stretch them. That's why lips also have grooves: they must be flexible to stretch.

Every person's chin is unique, too. Some have a dimple, others are angular, rounder, shorter, longer. The way the chin is connected to the neck varies from person to person as well.

*Practice drawing jaws and lips, anywhere from simple to more complex, using the method in the "Simplify" exercise (see page 48).*

WEEK 3

# A 3D HEAD

Let's apply the method right now. Here you can see simplified 3D versions of a human head. They look androgenous and are shown from two familiar perspectives. Your task is to draw these heads by copying what you see here—again and again, until you get a feel for the shape. The proportions are not realistic, but what's important here is that you understand the planes of the head.

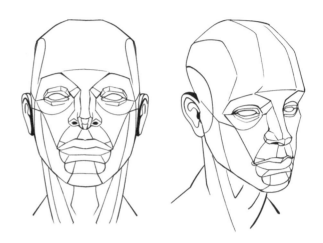

Try to remember everything you've learned so far:
angles, shapes, depth, volume, and perspective.

Forget about whether it looks good for now. With every repetition, your brain will absorb the information better, and you'll improve each time. My first attempts were absolutely unrecognizable.

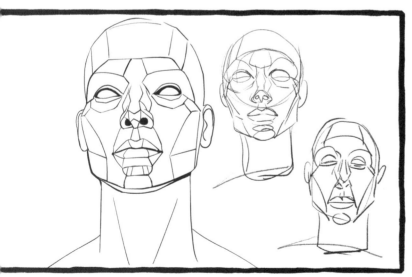

You can find more reference lines and step-by-step instructions for faces on the following pages. Here you're only learning about the different planes of the head.

52

# Exercise: Planes of the Head

Next step: Copy the head you see on this page three times onto a thin sheet of paper, then place it over the original to check how much your version deviates from the reference. Give yourself a break after each attempt and check where your lines are off. Which lines are too long? Where is the angle off? Which arc is not quite right? Keep this information in mind as you work on your next drawing. When you compare all three drawings at the end, you'll most likely see an improvement.

The point here isn't to draw great faces after a few days. That will take a long, long time. And these exercises alone won't be enough to make you proficient, either. But they're a good start. When you copy from a reference every day, you'll make considerable progress very quickly. This exercise, which I'm calling "three times a head," is always great because it doesn't matter in the slightest what the drawing looks like in the end. The important thing is that you learn!

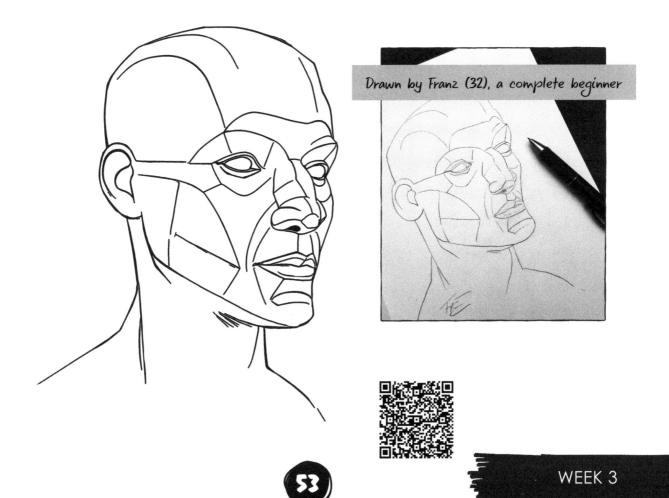

Drawn by Franz (32), a complete beginner

# Exercise: Reference Lines—Part 1

Now let's move on to the practical part. Here you see a simplified version of a head. It probably reminds you somewhat of the beginner's exercises we've done this week, right? The head is, as you may have noticed, not a ball. It's more of a sphere with flattened sides. Still, you can start with a ball. Reference lines will do the rest. You need to draw the reference lines according to certain rules. I'll show you one step at a time.

Let's go! Just draw along as I explain.

**1.** I start by drawing an oval. Then I add a couple of flattened corners on top to outline the forehead.

**2.** Then I draw two straight lines: a vertical line down the center and a more or less horizontal line about halfway down the head—as you can see, it's a bit more than halfway down.

**3.** The eyes sit slightly above the horizontal line, and between the eyes we have the nose. The exact location of each and the distances between them differ from person to person, but it's a decent start. Then I add reference lines below my first horizontal line. Do you see how they are all spaced equally apart? Use them as a guide.

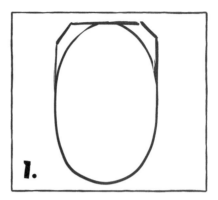

**1.**

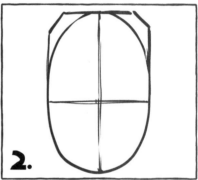

**2.**

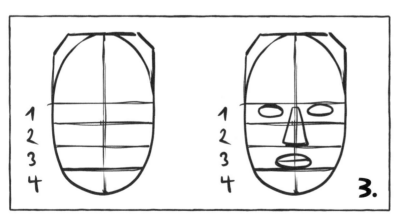

**3.**

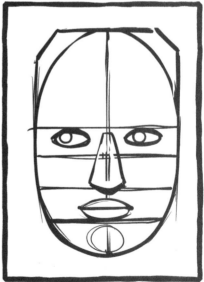

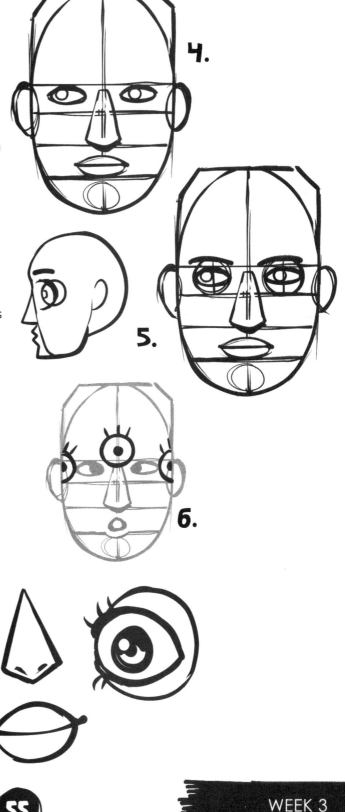

**4.** Usually the bottoms of the ears are on the same level as the tip of the nose (line 3), and the tops sit a little higher than the eyes (line 1). Sometimes they're also quite close to the eyebrows from this angle.

**5.** Eyebrows, by the way, are on top of the skin and don't necessarily represent the upper end of the eye socket. The eye socket, which you can see better here, sits more deeply inside the oval you created originally (from the side, a head looks more like a contorted balloon).

**6.** To simplify this, I sketch the eyeballs first and make them perfectly round. There's enough space between the eyes for roughly a third eye, and the space on the sides equals half an eye, more or less.

**7.** The nose is a triangle. The mouth is simply a pointy oval.

55

## Exercise: Reference Lines—Part 2

**8.** Now I sketch the cheeks by connecting the horizontal line below the eyes (line 2) with each corner of the mouth, one on the left and one on the right. It's the cheekbones, jawline, fat, and muscles that create the cheek lines.

**9.** Around the eyes, I sketch the eye sockets to get a better idea of the shape and volume of the forehead and nose.

**10.** I make the tip of the nose and the nostrils slightly round.

**11.** At this point I always refer to photos, depending on the person I want to draw, and then focus on shaping the forehead, cheeks, and jaw around the sides. Some people have a very angular jaw, others a very square one.

Also, depending on the face, I create additional reference lines of my own. For example, if the person I'm drawing has wrinkles, I can follow them easily. Very handy!

Drawing a head is like slowly chipping away at a chunk of wood to make a face emerge. At first, everything is very crude, but you reveal more details as you continue.

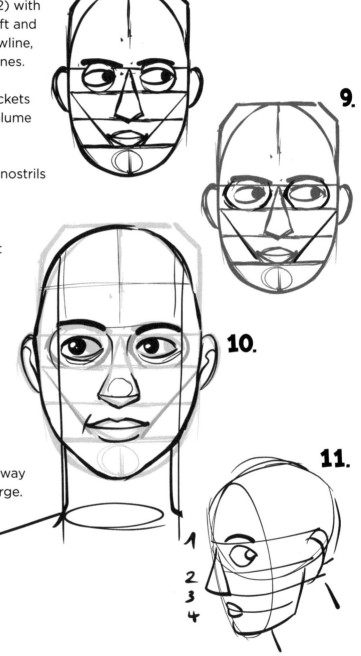

8.

9.

10.

11.

You can use these reference lines for any face. Different people have different faces. Some faces are longer, some are wider. Similarly, a person can be thin, fat, plump, tall, or short. You can modify the reference lines accordingly. Always use photos or videos—or, ideally, a living person—to guide you. You can practice very easily with a mirror or with friends and family.

Perhaps you're wondering why I've waited until now to show you these reference lines. The reason is that I don't want you to rely on them completely. Otherwise you'd always work with the same distances between the lines or confuse some lines and then draw a distorted face.

When you get to know the planes of a person's head first, you transfer that knowledge onto the reference lines. You're synthesizing information while you learn, but you also need a solid foundation before you become proficient.

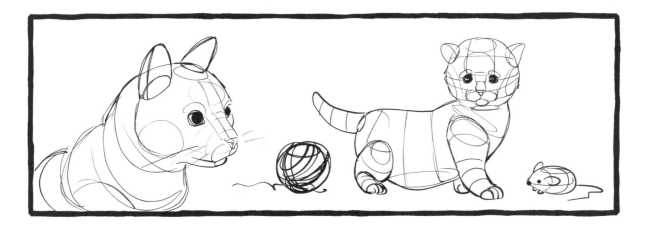

Once you can recognize the different planes, measure angles correctly, and understand depth, you can apply this knowledge to draw any object. The more you copy from a reference while you're learning, the better you'll be able to draw without one later.

# PRACTICING LINES

Now grab more photos of people and think about where the reference lines might go on those faces. Combine this approach with the exercises from week 3 as well: look at the planes within the grid and think about where those would be on the photo. Again, thin sheets of paper are great for seeing where your lines are off.

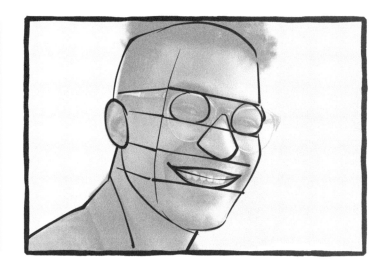

Young, old, female, male, androgenous, fat, thin, strong, lanky, or a unique style—the face looks drastically different depending on age and body type.

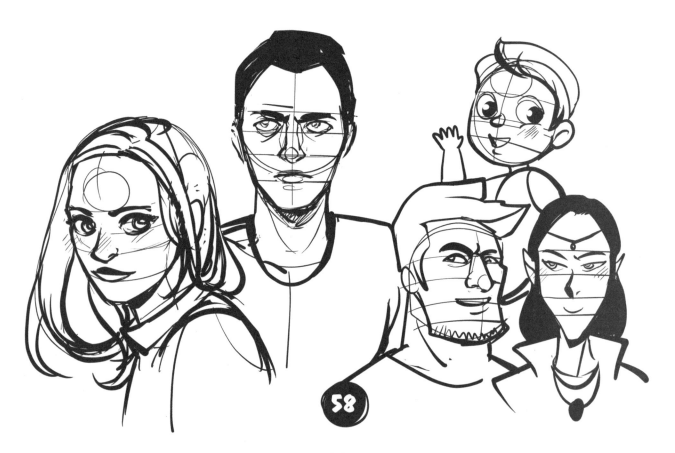

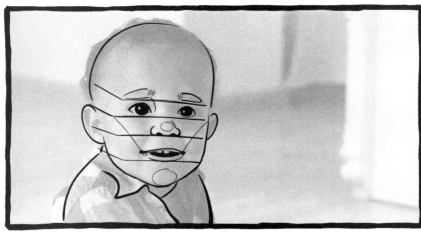

The head of a child is pretty round, and all features sit more closely together. The eyes are large, the nose is small and flat. The baby fat shows in the cheeks, and we see less of the neck.

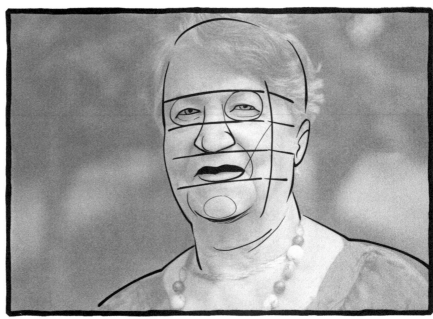

An older face has been subjected to lots of movement over the years. The skin is no longer tight, the lips are thinner, the nose often seems much larger. The eyes appear small.

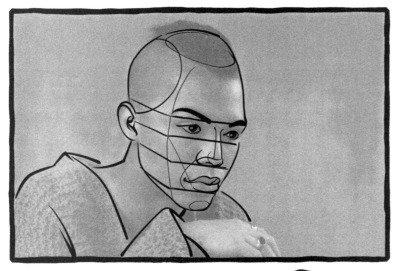

Androgenous faces show a combination of so-called masculine and so-called feminine features. Soft facial features are balanced with square ones.

# PRACTICE SCHEDULE WEEK 3

This week was packed with information. Don't expect to be able to draw a perfect face after a week's practice—because no one can, not even after several years of practice. There is no such thing as a "perfect face." But over time, your drawings will slowly approach your idea of what a face looks like. This week was meant to point you in the right direction so you can hone your craft. Studying an object's form can help you identify and simplify the planes of a more complex object. The way you get better at producing realistic drawings is by taking it one step at a time.

Background information: The better you understand complex forms, the more easily you can decide which lines are the most important. To draw a face, for example, which lines do you need to create a nose? With this knowledge, artists can make a face come to life with just a few strokes. The decisions you make about your linework based on your understanding of complex forms leads to what we call your "art style."

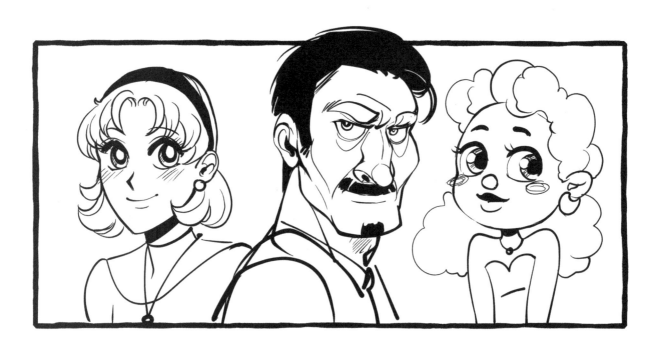

**Day 1:** Warm up, five tubes, one cube, and the exercises "Shapes" (see page 45) and "Simplify" (see page 48). Draw as many as you like.

**Day 2:** Warm up, five tubes, one cube, then draw a nose and eyes. Go over the theoretical sections on pages 49 and 50. Copy the noses you see there and study a few noses and eyes from reference photos. We've already practiced how you can identify planes, so just apply what you learned from that lesson. Simplify the eyes and noses and strictly follow the planes, angles, and line lengths.

**Day 3:** Warm up, five tubes, one cube, a nose, eyes, and lips. Yes, you're even drawing lips now (see page 51).

**Day 4:** Warm up, five tubes, one cube, and the planes of a head. Then draw a head like the one you see on page 53 by copying it three times. It doesn't matter in the slightest what your attempts look like in the end. You'll learn bit by bit as you practice. Draw more if you like.

**Day 5:** Repeat what you did yesterday but try to take longer this time if you can. Listen to an audiobook or start a nice movie while you work. Give yourself time to relax as you draw.

**Day 6:** Warm up, five tubes, one cube, and the planes of a head. Then draw a few heads with reference lines to guide you. If you don't have the time to do everything, choose only what you really need. Sometimes only five minutes of warming up are necessary.

**Day 7:** Repeat what you did yesterday.

The warm-up loosens your hand muscles, the tubes open your mind in terms of dimension, the cube reminds you of perspective, the planes of the head make you focus on shape and angles (which are the more important aspects of drawing), and the reference lines guide you safely through the maze to create a complex shape. If you repeat this sequence every day, you'll improve significantly within a short amount of time. And you don't have to draw heads every time—you can also try other organic objects.

Don't forget: Always measure the distances and angles by eyeballing it or using tools like the ruler, mentioned on page 15. That's how you create your own reference lines.

# WEEK 4

*Shadows*

63

Let's start with some exercises on light and shadows. Faces seem difficult, but they're a great way to learn how to draw fundamental features. You know what faces look like—and you've already practiced with them. For light and shadows, it also helps to break everything down into individual puzzle pieces.

You're going to find a lot of shapes to practice with this week. Each of these shapes reappears in more complex structures, too.

You'll also see many photos and 3D illustrations in the book again. Because no matter how well you can create a copy, it will always contain mistakes. Photos (and of course real people and real objects) allow you to study and practice capturing the way light falls on objects and creates shadows.

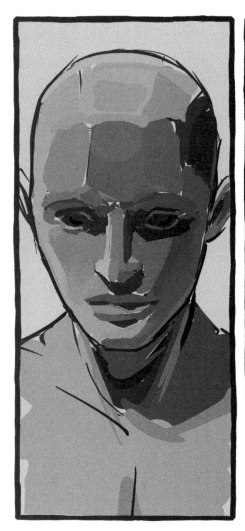
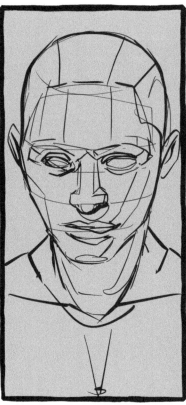
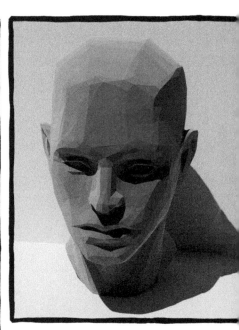

Again, you'll be practicing by copying but will combine several methods and go into more detail than in weeks 1 through 3.

64

To get you started, I'll show you how I proceed when I approach shadows. First, I outline the general shape, then I use a grid to identify the individual shapes. It doesn't all have to be correct. Examine the shadows and highlights and use those areas to guide yourself. Then simply start shading them in. You'll find an exercise for this on the next page. Here, you can just try to loosely copy what I did.

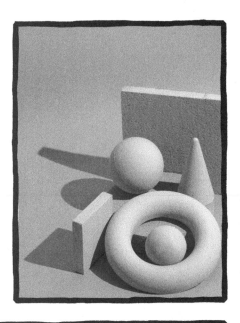

You can draw on this image.

You can draw on this image.

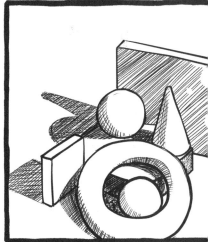

A pencil works particularly well for shading because you can achieve much smoother transitions with it. Use a piece of cloth or a blending stump to blur or blend the shaded areas.

# Exercise: Shadow as a Surface

The exercises you did in weeks 1, 2, and 3 are a lot to remember all at once, which is why you'll take it one step at a time now. This week, focus on perspective and shapes while you practice the new aspects.

Here you can see a sphere made up of rectangular faces. I've already created the different shades of darkness for you next to the drawing. Now you just have to follow the reference lines and apply the shading patterns you see—use the lines as a guide to know where one shading pattern blends into the next.

Draw shading pattern 1 into areas marked "1" on the sphere, then add pattern 2 to the area marked "2," and so on.

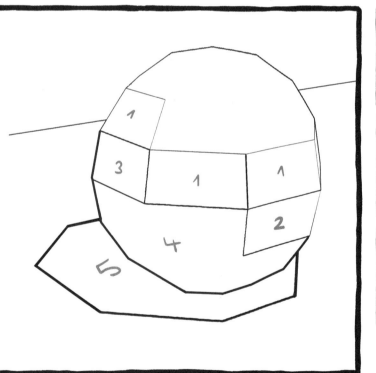

This is a bunch of spirals that create an increasingly tight and more dense shading pattern.

You can find additional simple line shapes with shaded areas using this QR code.

**66**

# Exercise: Crosshatching

Crosshatching isn't all that easy. You've already had an introduction to the topic during the fine motor skills exercises in week 1. Crosshatching is about achieving different tones—from light to dark—by layering multiple lines to create a more or less dense pattern.

For those of you working with pencil, charcoal, or pastel: lots of pigment on the paper creates a dark area, and less pigment creates a light area. For now, set aside these blendable materials and pick up a fineliner or ballpoint pen to create the patterns you see here.

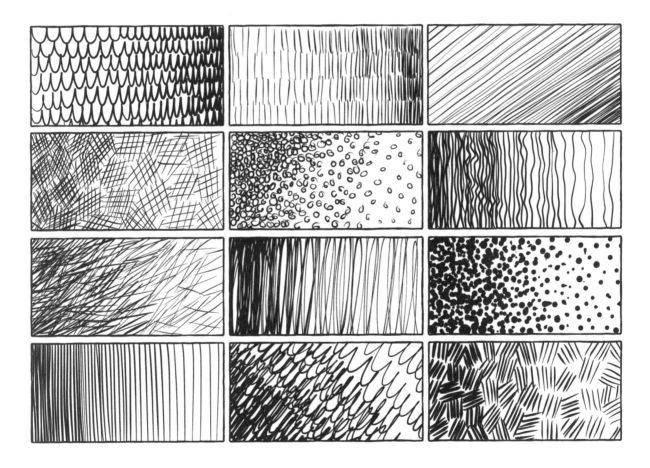

You can also come up with your own patterns or play around with crosshatching patterns you find online. These techniques are very old, and there are many resources on the internet about this topic.

# LIGHT AND SHADOWS

Using only lines to create a drawing is nice. However, you really get a sense of dimension and depth when you add shadows!

Now things will get a bit more complicated. But don't worry—you'll quickly get the idea once you've studied some clear examples.

Shadows are formed by the "absence" of light. Light consists of electromagnetic waves that originate from a light source. Your eyes perceive both the source and the objects where the light falls. The light bounces off those objects, making them brighter, and usually you can see the color depending on which electromagnetic waves are reflected. (The color spectrum isn't important for now, since this book is in black and white, anyway!) If the light reflection is low, the object or room appears dark.

*Your eyes perceive the reflected light and relay that information to your brain, which then tells you what is light and what is dark.*

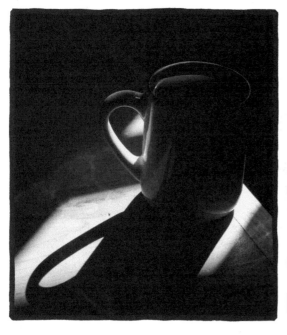
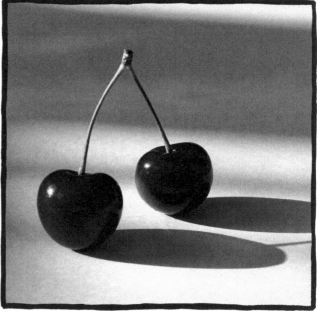

Only light sources can be completely white in their center. Highly reflective surfaces have a whitish glow because they reflect so much light. Look around you—there may be objects that you'd say are white, but any sheet of paper looks dark compared to a lightbulb or the brightness of the sky. Reality is what matters here. Photos are different because we can make them brighter by increasing the exposure time.

The effect of reflected light is similar to that of a light source. For example, that's why your face might look greenish when you stand in a room with green walls and a bright lamp. The walls reflect green light waves, which then give our faces that unfortunate hue.

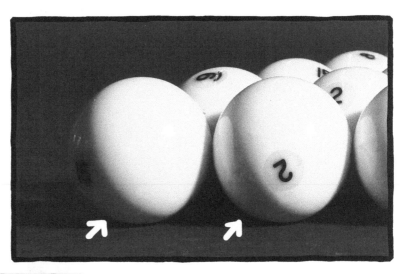

Any area where light waves can fall can be bright. The surfaces touched by light reflect its waves and create ambient light. Some surfaces hardly reflect any light at all, while others are transparent and change the color of the light. For example, light falling through red-tinted windows looks reddish because all other light waves are filtered out. This light becomes weaker, but it still illuminates the interior to some extent.

69

# A CLOSER LOOK

I'll use this sphere, which receives light from a single light source, to explain the terms you'll frequently come across when you study light and shadows.

**Core shadow:** the shadow in the area that hardly receives any light at all because the object itself blocks the light.

**Halftones:** the shading of the areas that are in a brighter range but not directly hit by the light source. You can see the colors quite well.

**Highlight:** the area where the light waves are most strongly reflected because the light source hits the object directly.

**Bounce light:** reflected light, such as on the surface below the object. You may even see some color or a reflection.

**Cast shadow:** the shadow created when the object blocks the light from reaching the surface behind it and casts a shadow opposite the light source.

**Crevasse or occlusion shadow:** the shading in the area where one object touches another (in this case, the surface underneath).

There's a mathematical formula to calculate where an object's shadow will fall, but that's beyond the scope of what you're learning here. If you want to know more about it, you can find resources online or watch the video using the QR code at the bottom of the page. For now, you'll stick to teaching your gut what feels right by copying images and studying references. However, it helps to remember some aspects of the formula to understand how and where shadows fall.

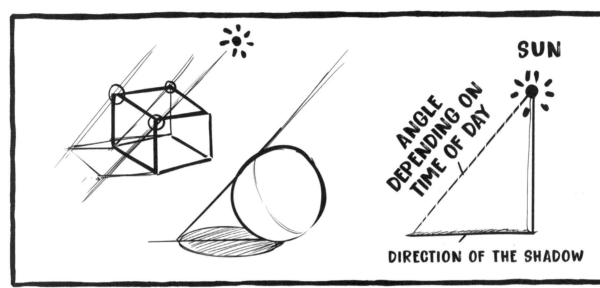

SUN

ANGLE DEPENDING ON TIME OF DAY

DIRECTION OF THE SHADOW

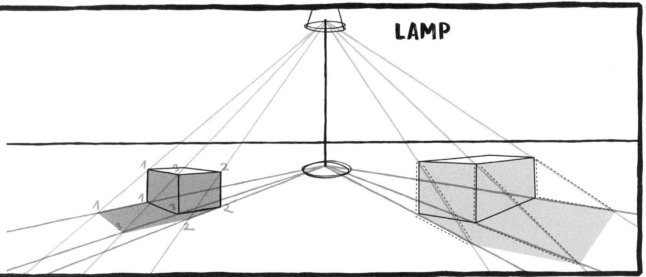

LAMP

I practice, explain, and apply the formula in this video.

WEEK 4

## Exercise: Form Studies

After all this theory, let's start your first exercise. On this page, you can see simple forms without any shadows, and on the next page, you can see the same forms with a cast shadow. Try covering the next page and shade in the areas where you think the shadow will be. Think of the formula, or, if that's too difficult, take a peek at the next page to see how you're doing.

Compare your results with those on page 73. Feel free to copy these objects several times and look for similar ones online. You can also create your own shapes with modeling clay or Play-Doh and use them as references.

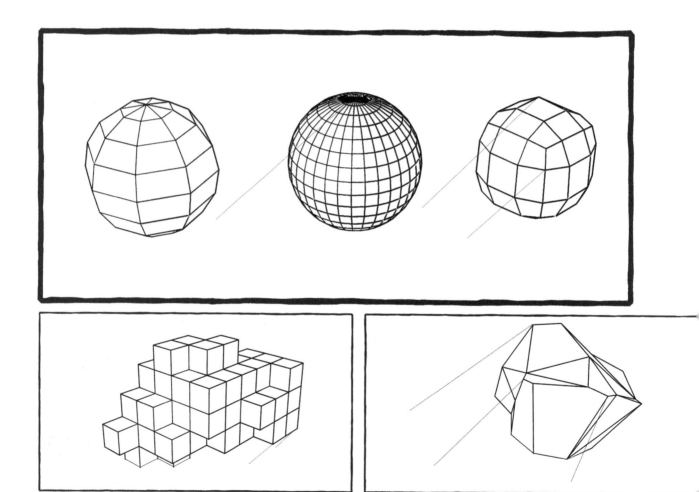

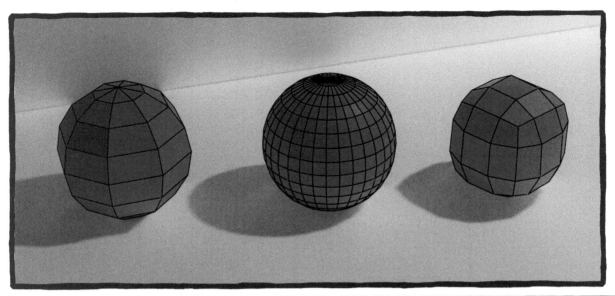

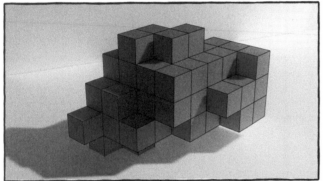

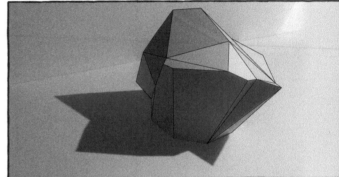

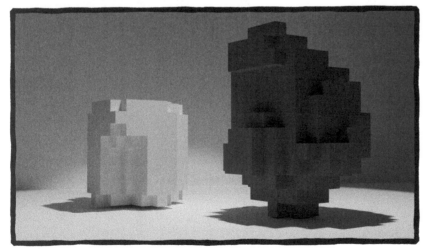

Depending on the drawing tool you're using, the results may be lighter or darker. That's okay. The point is to identify where the shadows are.

I've prepared a few more exercises for you here. If the soft transitions of the shaded objects are too difficult for you, remember: you can divide the shadows into individual shapes! You've already practiced crosshatching, so just use different pattern densities to create a transition effect.

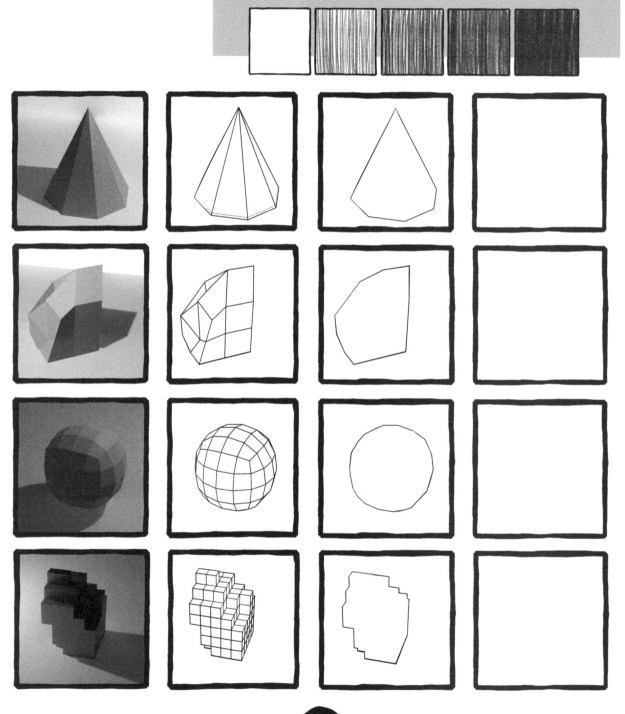

# PRACTICE SCHEDULE
# WEEK 4

**Day 1:** Crosshatching exercise as a warm-up (see page 67), then copy a simple object (see page 66) and use the shading technique with the spirals I showed you.

**Day 2:** Crosshatching exercise as a warm-up, then copy at least three simple objects as described on page 72. It doesn't matter whether you work with bananas or marbles, or use images from the internet or from this book—be creative and see which object makes a nice practice drawing. Use the QR code on page 73 to find more 3D examples.

**Day 3:** Crosshatching exercise as a warm-up, then draw tubes (see page 36) to get your three-dimensional thinking going. Finally, copy three different objects to study their forms (see page 72).

**Day 4:** Crosshatching exercise as a warm-up, then draw a few tubes and do the form study on page 72 three times. Finally, draw a head with reference lines (see page 54).

**Day 5:** Crosshatching exercise as a warm-up, then it's up to you. Pick exercises from this book you feel like doing today. Mix it up and combine a few of your favorites! For example, you could add shadows to the tubes.

**Day 6:** Crosshatching exercise as a warm-up, then roll up your sleeves—it will get more challenging. Grab the exercise "Planes of the Head" from page 53, draw a head, then try to add in some shadows on it. Feel free to use the internet to find more resources to help you.

**Day 7:** Crosshatching exercise as a warm-up, then break down the nose, eyes, and lips into simple shapes. Think back to week 3. Consider using a mirror. Make as few strokes as possible and find the familiar shapes you've been practicing with. Then add shadows on your shapes.

# WEEK 5

*Craft*

You already know that you can only draw what you've fully absorbed and understood. Technique plays an important role here. One of the most important techniques is working with a reference. Artists use references, and they usually work with more than one at a time. The better you understand the different elements of an object, the sooner you'll be able to re-create it from memory.

Here I explain in more detail what the difference is between a reference, a copy, and a traced image, and what to do with each.

A reference is a source of information that becomes an integrated part of your rendered drawing. For example, a reference can be a photo showing someone in a particular pose, a piece of clothing, the light and how a shadow falls, etc. You use your imagination to render most of the drawing, and the references help you with the parts that give you more difficulty. Basically, you're putting together a puzzle.

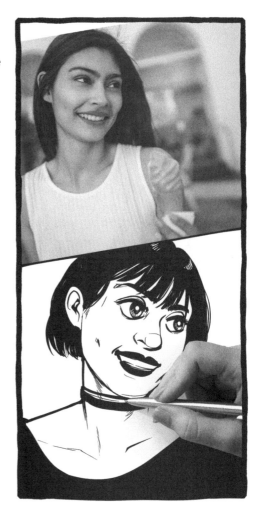

A copied image might be less creative but it is still valuable for you. You learn a lot by copying—and yes, it's still your creative piece. Please note that it is always illegal to copy someone else's original art and attempt to sell it as your own.

A traced image, on the other hand, is not creative work at all. Making an exact copy of an original is just that: copying. But you should still use this technique and add your traced images to your practice folder. By placing tracing paper or a thin sheet of paper on top of an image and simply following the lines underneath, you're training yourself on the concepts of shape and proportion. You create a composition before you actually sit down to create the final drawing. The traced image becomes a reference itself, so to speak.

# Exercise: References as Pieces of a Puzzle

A great way to learn about creating a motif for a drawing project is to do the following:

**1.** Write down your drawing idea and collect reference materials that represent pieces of your puzzle. They will become one image when you mix them all together.

**2.** The first step is easy: trace the references.

**3.** The second step is more challenging: copy the references.

**4.** Then use your creativity: compose your own sketch by copying different aspects of your references to create a unique image.

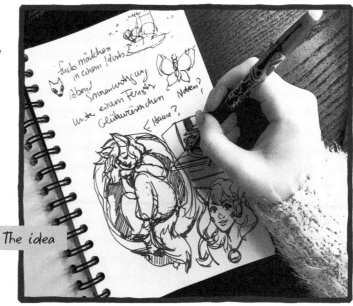

The idea

Photos and other references I used

My first composed sketch

Here's a video where you can learn more on the topic.

# A COMPLEX DESIGN

A perfect image tells your story. The process I showed you on the previous page helps you get closer to achieving this level of sophistication. Whether you want to draw a pretty face or a deeply emotional image infused with symbols that express your feelings, the story you tell with your art is partly up to you and partly up to the observer. Everyone experiences art differently.

There are other techniques besides using references that can help you put your ideas onto the page.

You already know about shape, depth, and dimension, as well as light and shadows. Now you'll examine a few additional elements that are also important:

- force/gravity
- movement
- aesthetics
- style

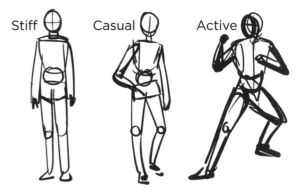

Stiff     Casual     Active

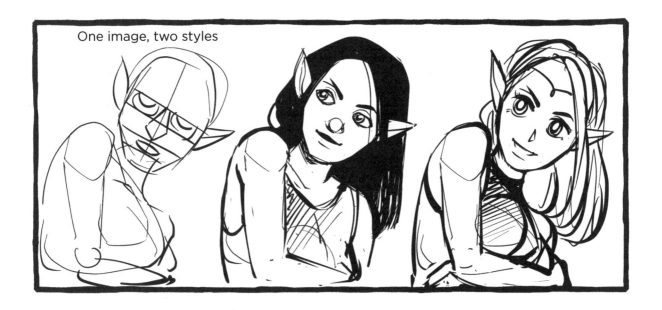

One image, two styles

# "GRAVITY?"

I didn't consider this aspect of drawing until much later in my art career. But gravity is important to make drawings look realistic. Examine the two figures you see here. One of them evidently jumps, the other one seems to hover somewhat limply in the air. To jump, you have to use your muscles to overcome gravity briefly. This energy is visible.

When the wind plays with the leaves of a weeping willow or when a small object is squeezed by pressure, forces play an important role, especially when it comes to balance.

See how these two people are standing? In one image, you can see that the person would fall over, no question. You don't have to witness it—your gut tells you this.

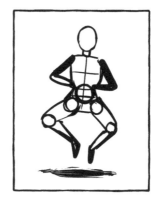
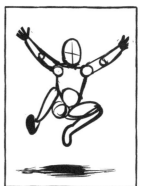
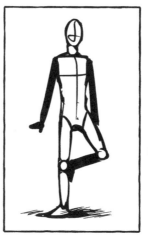
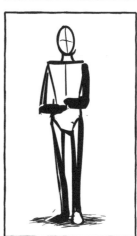

The forces that act in a drawing are very important.

An apple is said to have inspired Isaac Newton to develop his gravitational theory.

# BALANCE

Human bodies seem a lot more complicated than geometric forms. Still, you can very easily break down a person's body into simple objects, as you did in week 3. Let's dive a bit deeper now.

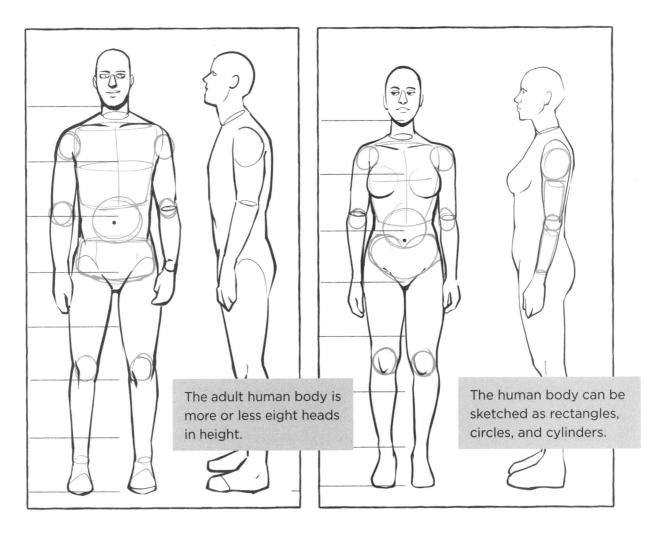

The adult human body is more or less eight heads in height.

The human body can be sketched as rectangles, circles, and cylinders.

These people look very stiff—like wooden figurines. Why is that? These drawings don't take into account the various forces that act on and within a human body: gravity, muscle tension, and kinetic energy. We move and shift our weight. The center of gravity is particularly important here.

# WHAT IS THE CENTER OF GRAVITY?

Every object has a center of mass, which is the part where gravity has the strongest pull. When you suspend an object from its center of gravity, it hangs completely still because its center of gravity lies directly beneath it.

You use your muscles to control your center of gravity—so you don't fall over—and shift your weight to stay balanced.

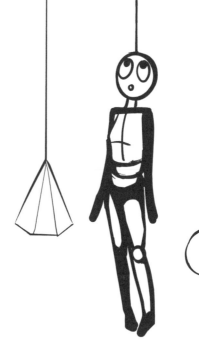

See where your own center of gravity is: let yourself fall face-first onto your bed. How far did you have to lean over before you lost your balance?

WEEK 5

# BODIES AND BALANCE

It's easier to practice with the basic shapes of a human body than it is to draw a realistic-looking person right away. On page 82, you learned how to break down a human body into simple forms. Let's simplify it even more by using stick figures.

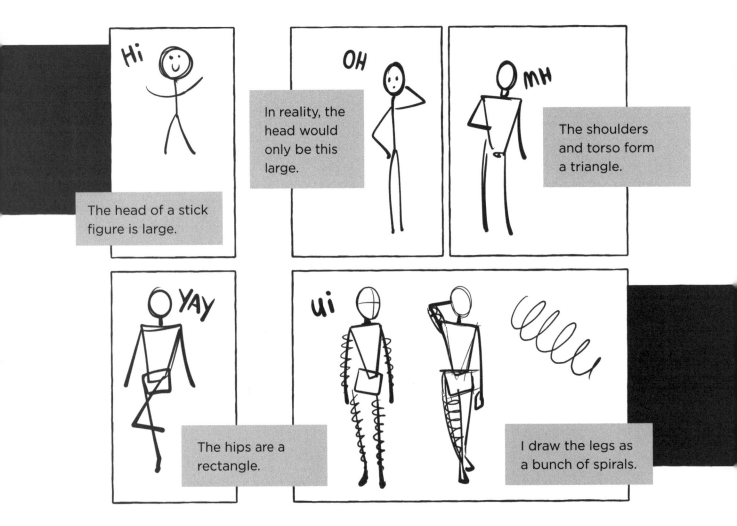

The head of a stick figure is large.

In reality, the head would only be this large.

The shoulders and torso form a triangle.

The hips are a rectangle.

I draw the legs as a bunch of spirals.

I imagine this stick figure is made out of wire. I can pull on one end, and the figure becomes taller and the body parts longer and thinner. I can press on it, and everything gets squished. Human bodies tend to be similar: different bodies may have different proportions, but a few basic principles always apply.

# Exercise: Stick Figures

Drawing more complex stick figures is a great way to practice poses. You can add more details if you like, as long as you convey two crucial aspects: the way people move and the forces that act on them. How do the figures shift their center of gravity? How might gravity affect them?

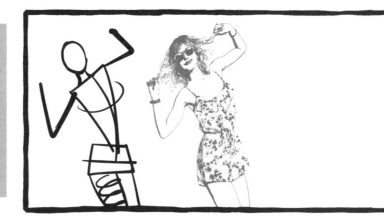

There are many ways to study dynamic poses. Observe people around you: friends, family, visitors at a park. Watch a movie or find photos on the internet that show the way individuals move. Then fill an 8.5 x 11-inch sheet with stick figures. They don't have to be big—about the size of your thumb—but draw them all in different poses. If you're unsure how long the different body parts are, refer to page 84 to refresh your memory. And don't forget about perspective: as we've learned, perspective can contract lines.

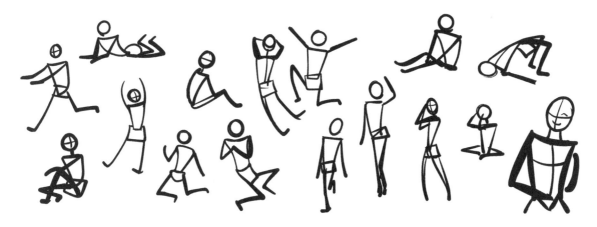

In this video, I show you how I draw stick figures and how I use them to study different poses.

WEEK 5

# DYNAMIC POSES

Perhaps you've already noticed that a pose, even when you trace it from an existing image, can still somehow seem static and stiff. Why is that? After all, you've created an exact copy.

Well, there are two explanations: First, it might have to do with your lines, which we'll get to later. Second, and this is the more important point here, our eyes are used to seeing movement, not still images. Yet we perceive more than just a person in motion because their surroundings play a crucial role: in real life, we see everything in the greater context. But all that is missing when you just trace a pose or draw a person in an empty space. That's why artists like to exaggerate their dynamic poses to emphasize the energy and the momentum in an image.

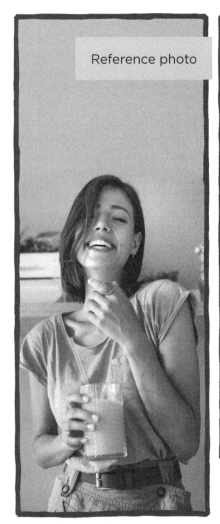

Reference photo

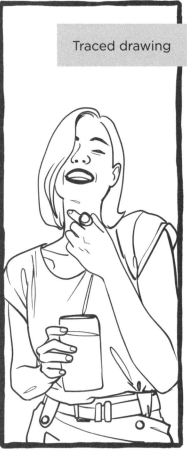

Traced drawing

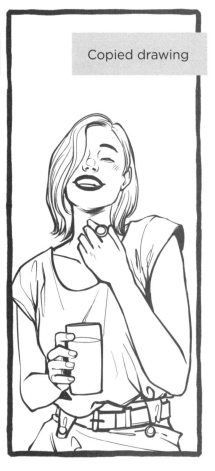

Copied drawing

# Exercise: Action Lines

By now you have an idea of how complex real life is and how many lines it would take to create a drawing that even remotely resembles an actual photo. Still, it's possible to render a realistic human body with a few lines. The real skill is in choosing the correct lines and placing them exactly where they need to go.

The style you choose is a matter of taste. However, no matter the style, all images have one thing in common: they show the momentum and power of a moving body, creating the illusion of movement. To master this, you must identify where the action lines are in a person. You already know how you can get there: copy from a reference. Do you see the line that runs down the center of both bodies here? Look for where this action line is in people around you, in photos, etc.

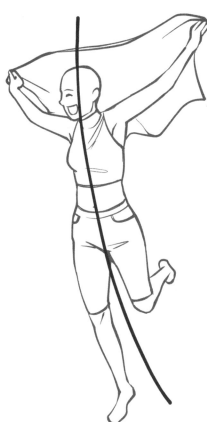

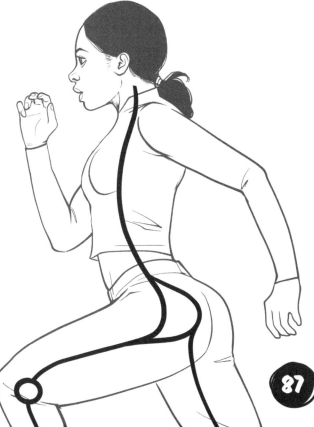

Draw some stick figures and incorporate movement by adding fluid action lines.

87

# STYLE

As I've mentioned already, deciding which lines you want to draw is a matter of style. All artists have different styles. You can see this particularly well in comics, where the illustrator might make some features stand out from the others. For example, an artist might emphasize the facial details or focus on creating contrasts, especially in the muscles.

The style you choose can emphasize the story you want to tell. Your drawing of an everyday young woman, for example, may focus on different aspects than your drawing of a superhero in their superhero costume. Your unique style can emerge all on its own, but you can also apply a particular technique to achieve a desired effect.

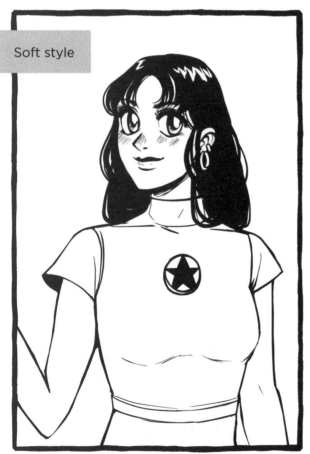

Soft style

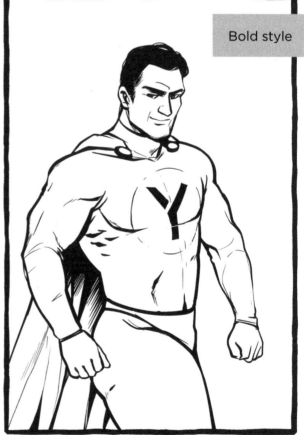

Bold style

Here we see four images of superheroes that show varying styles. With the first soft-style image, we are drawn to large glittering eyes, fine curved lines, the details: these aspects highlight the beautiful features of this one superhero. To draw a more muscular superhero, however, we may want to use a different style. For example, we can underline the character's strength by creating bold lines and features. The bold-style superhero on page 88 shows a strong chin and hard jawline, which gives him a more chiseled look. Even if we used softer strokes, his posture would remain dominant. In the end, it always comes down to taste, and no style is wrong.

When you like a drawing, ask yourself: "What do I like about it? What don't I like about it? And what do others think?" This way, you'll find your own style over time.

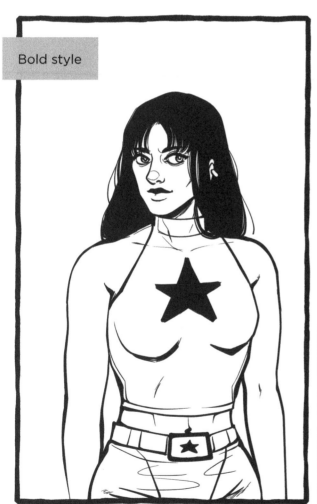

Bold style

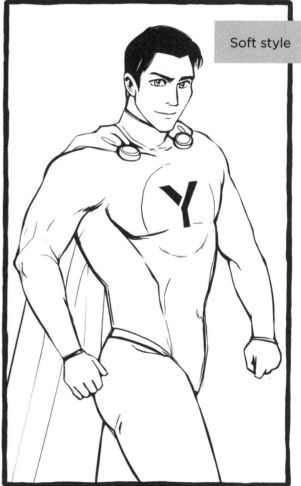

Soft style

A professional artist can change their style as they wish, depending on the client and what kind of story they want to tell..

WEEK 5

We've reached the last few pages of this book. Before we finish, let's add gravity and action to the formula we've been using:

> Shape + perspective + light and shadows + creativity + gravity and action

I want to touch briefly on another aspect: aesthetics.

We could fill an entire book on this topic, so I'll focus on a few tips and let you discover more on your own, if you're interested. Note that you can also draw without a focus on aesthetics because drawing is about technique and skill, not beauty.

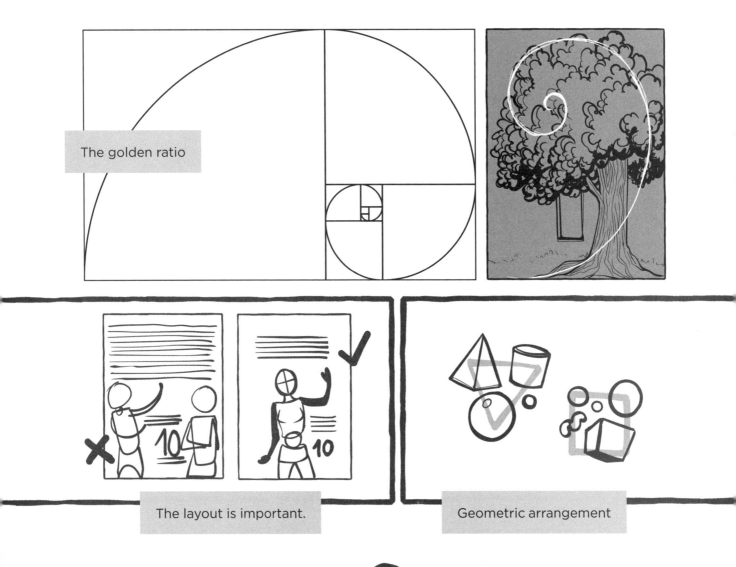

The golden ratio

The layout is important.

Geometric arrangement

# Exercise: Thumbnails

On the left-hand page, you see the so-called golden spiral, a spiral that gets wider by the golden ratio with every quarter turn. Spend some time studying it to understand it better. It will allow you to compose captivating images. Next, let's talk about thumbnails, which are small, concise versions of a larger piece of art. You'll find several examples on this page.

Thumbnails help us to find the best image composition: you arrange all elements of the image to see whether the image achieves the desired effect.

You might find the image in the middle particularly pleasing—it looks well composed and harmonious. If we place the golden ratio over it, we can see that the elements on the image align nicely with the spiral.

It's not a secret formula, and it doesn't work all the time. But it's one of many ways to create a well-designed image. Other aspects, such as the illustration's emotional message, can be just as important. And sometimes you have to forgo aesthetics altogether to make a scene appear threatening, oppressive, or eerie.

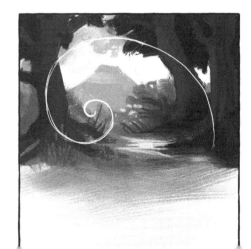

91

# PRACTICE SCHEDULE WEEK 5

**Day 1:** Warm up, then draw five tubes followed by three simple objects using perspective.

Afterward, think about a drawing you'd like to create this week. It doesn't have to be anything special—it will just be for practice. Start by jotting down notes on what the drawing is supposed to illustrate, then find references for your drawing idea (see page 79). Finally, fill an 8.5 x 11-inch page with stick figures (see page 84) and pay attention to the action lines (see page 87).

**Day 2:** Warm up, then draw five tubes followed by three objects using perspective. Afterward, remember the drawing idea you had yesterday. Take the references you collected, and trace them once and copy them twice.

**Day 3:** Warm up, then draw five tubes followed by three objects using perspective. Afterward, create a few thumbnails to choose the best composition for your drawing idea (see page 91). Simple shapes are enough—remember the rough drawing I showed you on page 79. You can use additional references to compose your thumbnails.

**Day 4:** Warm up, then draw five tubes followed by three objects using perspective and more thumbnails.

**Day 5:** Warm up, then draw five tubes and three objects using perspective. Now it's time to put your drawing idea onto the page. On your first attempt, just focus on practicing—don't try to create anything perfect. Grab your reference images and spend the rest of the week working on your drawing. Create and discard as many drafts as you like.

**Day 6:** Warm up, then draw five tubes and three objects using perspective, then continue working on your drawing.

**Day 7:** Warm up, then draw five tubes and three objects using perspective, then finish your drawing. I'd love to see your progress, so please feel free to send me a picture of your final version on Instagram or Twitter using the hashtag #KritzelPixel.

# IT DOESN'T END HERE!

First of all, thank you for buying this book. Let me know what you thought of the exercises—I'd greatly appreciate your feedback.

I hope the last few weeks have provided you with enough of a foundation to practice on your own from now on.

Before you begin with a new drawing project, make sure you prepare first and study the references and objects you need to create what you have in mind.

I sometimes browse magazines and the internet and look at the drawings of others to get ideas for my own work. A sketchbook is a great tool to record anything that crosses your mind—and it's okay if you don't love your work. I know there are amazing sketch artists who turn their sketchbooks into masterpieces, but that is their choice and not necessary. I only need my sketch pad for practice, anyway. After all, the purpose of practice isn't to create finished pieces.

Here's part of my daily drawing routine and what I recommend you do as well:
I do five minutes of warm-up and then draw five tubes and three simple objects. Afterward, I trace a reference, then I copy it. I create another copy, but this time I make small modifications to it. Finally, I practice something more challenging, like drawing using perspective, working with light and shadows, etc. It depends on what I feel like doing that day.

Go ahead, give it a shot! I hope that you're inspired to keep going and that your exciting journey into the wonderful world of drawing doesn't end here.

Drawing is practice, practice, practice: it's a never-ending journey. The big secret here is to understand the world you observe around you.

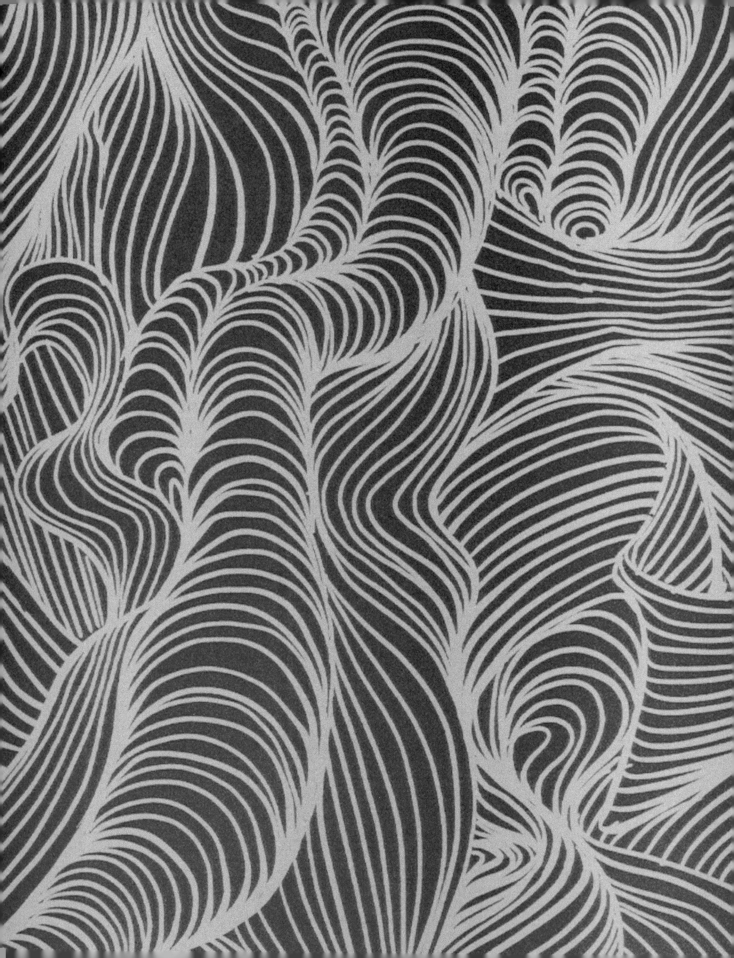

# Additional resources and my knowledge library

Bridgman, George B.: *Constructive Anatomy* (Dover Anatomy for Artists)

Guptill, Arthur: *Rendering in Pen and Ink*

Gurney, James: *Color and Light: A Guide for the Realist Painter*

Robertson, Scott, with Thomas Bertling: *How to Draw: Drawing and Sketching Objects and Environments from Your Imagination*

Robertson, Scott, with Thomas Bertling: *How to Render: The Fundamentals of Light, Shadow and Reflectivity*

Hi there,

We hope you enjoyed *Learn to Draw in 5 Weeks*. If you have any questions or concerns about your book, or have received a damaged copy, please contact customerservice@penguinrandomhouse.com. We're here and happy to help.

Also, please consider writing a review on your favorite retailer's website to let others know what you thought of the book!

Sincerely,

The Zeitgeist Team